TOTEM POLE CARVING

TOTEM POLE CARVING

BRINGING A LOG TO LIFE

Vickie Jensen

Douglas & McIntyre
Vancouver/Toronto

University of Washington Press
Seattle

First paperback edition 1999
05 06 07 08 09 5 4 3

Douglas & McIntyre Ltd.
2323 Quebec Street, Suite 201
Vancouver, British Columbia
Canada V5T 4S7
www.douglas-mcintyre.com

Published simultaneously in the United States by
University of Washington Press
PO BOX 50096
Seattle, Washington 98145-5096
www.washington.edu/uwpress

Library and Archives Canada Cataloguing in Publication

Jensen, Vickie, 1946–
 Totem pole carving
 Previous ed. has title: Where the people gather.
 Includes bibliographical references.
 ISBN-13: 978-1-55054-747-4 ISBN-10: 1-55054-747-X

 1. Totem poles—British Columbia. 2. Niska wood-carving.
3. Totem poles—British Columbia—Pictorial works. 4. Niska wood-carving—
Pictorial works. I. Title II. Title: Where the people gather.
E98.T65J45 1999 731′.7 C99-910623-6

Library of Congress Cataloging-in-Publication data is available.

Editing by Saeko Usukawa
Book design by Barbara Hodgson
Cover design by Val Speidel
Typeset by Compu Type Inc., Vancouver, BC

Printed and bound in Canada by Friesens
Printed on acid-free paper

We gratefully acknowledge the financial support of the Canada Council for the Arts, the British Columbia Arts Council, and the Government of Canada through the Book Publishing Industry Development Program (BPIDP) for our publishing activities.

Published with assistance from the British Columbia Heritage Trust.

CONTENTS

FOREWORD

When Vickie Jensen came to me and asked my permission to document and record the carving of the Native Education Centre totem pole, I was reluctant to accept her proposal. I immediately imagined a camera and a tape recorder distracting me from teaching and carving.

I thought about her offer for many days and agreed to go ahead because most poles have only sporadic pictures taken of them and occasional interviews with the artist. The next thing you know, the pole is raised and only the carvers are aware of how it really happened. No one knows the sweat, the problems, the camaraderie and sacrifices that go on behind the scenes. So I said yes and hoped for the best.

In fact, the documentation project turned out to be fun. It was a real morale booster for the crew, and I was glad for that. The carving shed was visitor-restricted, so there weren't many people out there regularly except Vickie. The crew really looked forward to her visits. The talk and the contact sheets and the food she brought kept them going. I could always tell when she had been out for a session.

I think the project helped to settle the crew down. They talked about what the book might say and wanted to see it succeed. It encouraged them, and they tried just that little bit harder. Being interviewed helped them put words to the experience of carving and helped them to understand who they were. They didn't realize they had it in them. But when the carvers heard themselves talking, they heard their own power.

The first draft of the book proved to me the value of this documentation. Throughout the pages, I recognized the style and quirks of speech of each person.

I began to feel myself drifting back to the beginning of carving the totem pole and physically felt back in the Museum of Anthropology's carving shed, working and teaching all over again. Back then, I wasn't sure whether I was carving a totem pole or developing people. Most of the crew were relatively new at carving and unsure of moving onto the next task. The book made me turn around and take a closer look at the crew. Listening to the interviews and reading the manuscript made me realize that they'd taken a chunk of my heart.

When the totem pole was being raised, I was elated and felt great pride for the carvers and the celebration that went on. This pole taught all of us, especially me, the value of perseverance. We experienced a tremendous spiritual growth and a tighter family bonding which helped us to complete the pole. This book brings that all back. It is a monument to those who worked on the pole and all who helped with the ceremonies.

As an experienced Nisga'a carver, anything I do inspires young carvers. They come up to me and are proud to say ''I'm carving now.'' I think the book will continue that inspiration and even help other carvers who might not have tackled a major project yet.

Few people ever have the opportunity to watch the completion of a mask or any piece of Northwest Coast art, much less an entire totem pole. *Where the People Gather* takes you behind the scenes, into the carving shed. It's almost like being there. On a big project like this pole, a carver works all day, takes his thoughts or problems home and comes back and carves them out the next day. This book captures a lot of that.

The words and photographs give the perspective of the whole crew, rather than just an interview with the head carver. You have the chance to get to know individuals as well as the collective personality of the group that carved this monumental work of art. The learning, teaching and feelings of all of us—as well as our carving skills—are reflected in this pole. There's also the importance of our family support, the traditions we are bringing forward that make this pole distinctly native, and the community involvement that helped raise it. This book is the chance to get close to all of that—it's the printed experience of a totem pole coming to life.

—*Norman Tait*
1992

PREFACE

Norman Tait has regularly asked me, as a long-time photographer and friend, to document his work. However, in fifteen years of photographing his art and that of many other native carvers on the Northwest Coast, I had never recorded the start-to-finish process of a large carving project. When I proposed such an idea to Norman, he said, ''Let me think about it.'' A week later he called back to say he had just received a commission to carve a 42-foot ceremonial doorway pole for the Native Education Centre under construction in Vancouver, British Columbia. The job started immediately. Was I interested? You bet I was!

Over the next three months, I learned a great deal about carving totem poles and about native teaching styles, opening my mouth less and my eyes more. I learned when it was important to stay out of the way, when questions could be asked and when to be quiet. My research project soon grew into a mutual respect and friendship with the carvers that included listening to their hopes and frustrations, trading jokes as well as confidences, and cooking up enough lasagna or chili to satisfy the crew's formidable appetite. (Norman later explained that feeding the crew was most appropriate, since it was the traditional responsibility of anyone wanting to join in the prestige of the pole.)

Because carvers seldom have their work documented in detail, the crew was particularly appreciative when I arrived at the carving shed with a newly printed stack of photographs. Norman occasionally used these pictures to assess progress on the pole, in one instance deciding to cut a figure deeper. After the first month, foreman Chip Tait felt free to point out a particular stage, angle or technique that he felt should be recorded. Darkroom work consumed hundreds of hours.

In the end, I amassed over 2200 negatives and 800 colour slides.

Initially, I thought this book would tell its story primarily through photographs. But early on I realized that what the crew members were *learning* was equally as important as what they were *doing*. So the text came to assume an importance equal to that of the photographs, especially since only five per cent of the total photographic documentation could be included in the final publication. The process of tape-recording the work sessions and of interviewing the crew began right after the log was moved to the carving shed. Before that, however, I had made notes of conversations, beginning when Norman first saw the cut log. In all, there were twenty-five hours of tape-recorded carving sessions and interviews. The quoted remarks of the carvers have occasionally been shortened in the book, but not altered in meaning. I took pains to keep the flavour of the carvers' ways of speaking, particularly the repetition patterns that are characteristic of native speech. The project was always a team effort, and the carvers approved drafts of the manuscript as it progressed towards publication.

It is not easy to render in English the complex sounds and structures of native languages on the Pacific Northwest coast. Over the years, many people have tried with varying results. For example, Nisga'a, the native nation to which Norman belongs, is also written, Nishga, Nisga', Nisgha, Nisgah, Nisgaa, Niska and Niskae. Throughout this book, I have endeavoured to use the spellings currently in use by the Nisga'a Tribal Council and the writing system from the *Haṅiimagooṅigumalgaxhl Nisga'a/Nishga Phrase Dictionary*, published by School District 92 (Nishga) and edited by Marie-Lucie Tarpent.

The pole's name, Wil Sayt Bakwhlgat, means ''the place where the people gather.''

There is no single way of carving totem poles, as other native artists know well. But all carvers do go through a similar process, including the designing, contracting, first cuts, roughing and finishing stages of the pole. Some prepare for this work with an inner cleansing or purification. Ceremonies to welcome and raise a totem pole are also an integral part of the carving process. Today, carvers use chainsaws as well as a variety of hand tools such as adzes and curved knives, which most artists make for themselves. While the details and circumstances for each pole will vary, any major project involves assembling and keeping a crew, preventing injuries and meeting deadlines. As Norman once speculated, ''There probably never was a pole carved without tension.'' This pole is no different.

One might ask, ''If you're going to write a book about carving a totem pole, why not choose a really experienced crew?'' Indeed, only Norman and Chip Tait were accomplished carvers, so initial progress on this pole was slow. But documenting the efforts of a master carver, his first-time foreman, a journeyman carver

and two apprentices afforded the rare opportunity to record styles of teaching, smithing tools and making regalia, as well as practice sessions for the songs and dances used in the raising ceremonies. Furthermore, this pole reflected Nisga'a tradition in that it was carved by one extended family. So, in many ways, this was exactly the right pole and crew for the book.

Indeed, Wil Sayt Bakwhlgat served as a most memorable teacher for all of us.

This book is for Norman Tait—and for Chip Tait, Hammy Martin, Wayne Young and Isaac Tait. Their good will, friendship and skill made it a true collaborative effort.

Over the years I worked on this book, four women greatly facilitated my documentation of the totem pole. They are Reva Robinson, Cheryl Patricia Higgs, Hilary Stewart and Hope Tait. I particularly appreciate their insight and help.

Others who critiqued early versions of the manuscript and provided valuable suggestions are: Doreen Jensen, George MacDonald, Marjorie Halpin, Peter Mac-nair, Mercy Robinson Thomas, Max McNeil, Bill Holm, Mardonna Austin-McKillop, Joy Tataryn, Judy Cranmer and Michael Batham.

I would also like to thank the staff of the University of British Columbia's Museum of Anthropology, Andrea Laforet and Pam Coulas of the Canadian Museum of Civilization, Howard Green and Ron Short of the Native Education Centre, Henry Tabbers of the Vancouver Museum, Susan Marsden of the Museum of Northern British Columbia, Carolyn Blackmon of the Field Museum of Natural History, and Ksim Sook (Nita Morven) and Marie-Lucie Tarpent for their assistance with Nisga'a orthography. Thanks also to Saeko Usukawa and Rob Sanders of Douglas & McIntyre for their enthusiastic interest in the manuscript and their willingness to undertake the editorial process with me halfway around the world.

Finally, this book is lovingly dedicated to my husband, Jay Powell, and our sons Nels and Luke.

TOTEM POLE CARVING

THE BACKGROUND

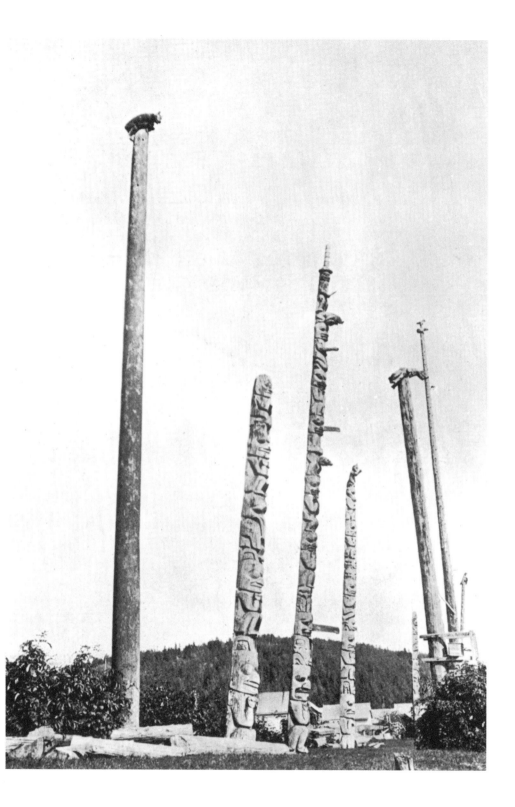

This early Barbeau photograph shows totem poles of Gitlax̱t'aamiks village, on the Upper Nass River. *National Museum of Civilization, 100438*

INTRODUCTION

No one knows who carved the first totem poles or when. And the people who could have recounted the stories about those early poles have long since passed on. But careful examination of the records of early European explorers to the Northwest Coast suggests that totem poles were in evidence when their ships first contacted Haida and Tlingit villages over two hundred years ago.

As trade between Europeans and native people was established, iron tools for efficient carving became available and native wealth increased. This combination fuelled a tremendous growth in the kinds and numbers of totem poles that were carved in the nineteenth century.

The Nisga'a are part of the Tsimshian language group, along with the neighbouring Gitksan, Coast Tsimshian and Southern Tsimshian. Like many other Northwest Coast groups, they carved their monumental sculptures from red cedar. Much of the recorded information about older Nisga'a totem poles comes from Marius Barbeau, an ethnologist who worked for the National Museum of Canada. During the 1920s, Barbeau travelled in British Columbia and Alaska, documenting stories and poles of the Nisga'a and their relatives, the Gitksan and Tsimshian. He noted that in 1927 more than twenty Nisga'a poles were still standing from the mouth of the Nass to midway up the river. Barbeau states, "The Poles of Nass River tribes were among the finest and most elaborate in existence, ranging up to 80 feet in height."

Forty years later, none of those poles remained standing where they had been so proudly raised. A few old Nisga'a poles were acquired for museum collections at the University of British Columbia's Museum of Anthropology (Vancouver),

4

Ready to raise the Port Edward pole, Norman Tait wears a ceremonial button blanket and cedarbark rainhat. His father, Josiah Tait, stands on the far side. *District of Port Edward and Museum of Northern B.C.*

the British Columbia Provincial Museum (now the Royal British Columbia Museum, Victoria), the Royal Ontario Museum (Toronto), the National Museum of Canada (now the Canadian Museum of Civilization, Ottawa), the Museum of Northern British Columbia (Prince Rupert), Le Jardin Zoologique (Charlesburg, Quebec), the British Museum (London), the Royal Scottish Museum (now the National Museum of Scotland, Edinburgh) and Le Musée de L'Homme (Paris).

Then, in 1973, young Nisga'a carver Norman Tait and his father, Josiah Tait, were commissioned to carve a 37-foot totem pole to commemorate the official incorporation of Port Edward, a cannery town just south of Prince Rupert that was populated by seasonal workers from a variety of native villages on the coast. This was the first Nisga'a totem pole to be raised in over half a century. Two years later, a second smaller pole of Norman's was erected at the head office of the first native-run cannery in Port Simpson.

Since then, Norman Tait has gained considerable knowledge and experience. In three decades of work, he has carved over thirty poles, monolithic doors, canoes and welcome figures; his totem poles stand on three continents. (See Appendix 2 for a full list of these major pieces.) In addition to large projects, Norman has also designed silkscreen prints, made button blankets, and produced numerous

smaller carvings in wood, precious metals and gemstones, bone and ivory. His art is sought after by collectors in North America, Europe, Japan and Australia.

Old or new, totem poles evoke curiosity, admiration and wonder. ''What do they mean?'' ''How are they carved?'' and ''Why?'' Even those who know these striking cultural artifacts have questions and opinions. ''Why was it carved that way?'' ''How does this pole differ from others by the same carver or group?'' ''How does it measure up in terms of artistic quality?'' Fortunately, the recent resurgence in carving on the Northwest Coast has been matched by an increasing number of published resources that help answer these questions.

But up until now, the study of totem poles has been largely limited to looking at them *after* they have been completed. This book examines the actual process of carving a modern pole. Part I provides background information and an introduction to the carver, his family and lineage, followed by the story that inspired the design of this particular pole. Part II, the main body of the book, documents in photographs and text the actual carving of Wil Sayt Bakwhlgat, Norman Tait's magnificent 42-foot totem pole.

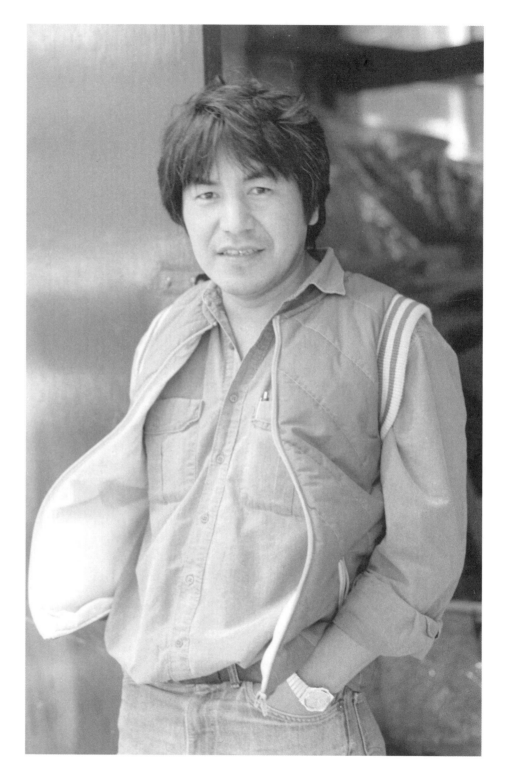

In two decades of work, Norman Tait has carved over twenty poles, monolithic doors, canoes and welcome figures; his totem poles stand on three continents.

NORMAN TAIT:

NIS<u>G</u>A'A ARTIST

Norman Tait was born to Josiah and Sadie Benson Tait in 1941, in the Nisga'a village of Kincolith at the mouth of the Nass River in northern British Columbia. Norman describes Kincolith as one of the first villages on the Nass established by native Christians; hence most aspects of native culture and art were discouraged, although the Tait household spoke Nisga'a first and English second. A few years after the family moved to the nearby town of Prince Rupert, six-year-old Norman was sent to an Indian residential school in Edmonton. Cut off from his family and forbidden to speak his native language for most of the year, Norman did come back to spend summers with his family in various cannery villages, where he fished with his father. After six years of residential schooling, Norman was returned to his family and lived with them until he finished high school in Prince Rupert. Although trained as an accountant, he worked as a millwright for Columbia Cellulose. Norman married Jessie Angus, also from Kincolith, and they had a daughter, Valerie, and a son, Isaac. In the early 1970s, the young family left the security and familiarity of Prince Rupert to try life in Vancouver.

Norman is the eldest male of the Tait children. They are, in order of birth: Stella, Liz, Grace (also known as Hope), Norman, Alver, Ken (deceased), Sandra and Robert (or Chip). Jimmy, a nephew, was also raised by the Taits. Two other brothers, Joey and Mark, both died as young children.

The Nisga'a, like some Northwest Coast native groups, are a matrilineal culture that differentiates clans. Josiah Tait was the ranking Wolf clan chief and carried the name T<u>x</u>aatk̓wigaa<u>k</u>s before his death in 1990. He was a fisherman and part-time trapper who carved for his own pleasure before suffering a disabling

stroke in 1975. Norman received his first training about wood from his father.

Their mother, Sadie Tait, is Eagle clan, a heritage and identity that she passes on to all her children in the Northwest Coast matrilineal kinship system. Her Nisga'a names are Xiinak̲ and Nits'iits Sigeehl. The nephews and nieces born of Norman's sisters are also Eagle clan. Norman carries two Eagle names. His first name, Ṅaaẁitkwhl (lik'iṅsk la x̲ g̲alts'ap), was earned for carving a 55-foot totem pole in Chicago and raising the status of his family. The most powerful is Gawaaklh, a hereditary name he inherited from the older brother of his maternal uncle, Rufus Watts. Each name means he is the head, or chief, of a separate Eagle house and carries its leadership and responsibilities.

Two of Norman's children, Valerie and Isaac, are Frog clan, inheriting their rights from their mother, Jessie, now deceased. Both have studied carving with their father and their uncle Chip. Norman also has a younger son, Micah, by Cathy Cohen-Tait, his second wife. Cathy was adopted into the Wolf clan, so Micah is also a Wolf. For several years, including the time he carved the Native Education Centre pole, Norman's companion was Reva Robinson. After that, he was with Cheryl Patricia Higgs, who also promoted his work. Since 1991, Norman has been carving with partner Lucinda Turner.

"The old way of apprenticing," says Norman, "was that my uncle (mother's brother) would consult with the family and decide if he wanted me to become a carver. If my ancestors were carvers, then definitely he would have taken me as the first son, or all of us brothers, and handed us over—literally handed us over—to a master carver. For a year we would have followed him around and not done any carving. We'd just exist virtually as slaves to do all his rough work, clean up after him, keep his tools sharp and so on. If he wished, he could dismiss us at any time and send us back to the family in disgrace. If we made it as a carver, we'd become one of the highest-ranking persons, well known up and down the coast.

"Nowadays, it's a little different. Most guys sort of drift around, hang around, until they find out that they can carve. Then they go and look for someone, someplace where they can learn.

"I just touched carving, off and on, for a long time. I carved my first pole when I was eight years old. I don't even remember how it looked, because my brother didn't recognize it was a pole and chopped it up for kindling!

"In Edmonton at the Indian residential school, I started to carve a bit, but there were already established carvers who just made fun of anyone else who tried to get going. So I just left it at that until '59, I guess it was. I forgot all about carving again until I graduated and got married to Jessie. Then I did a little work on it, nothing serious. Sort of just a hobby with a pocketknife and some sandpaper.

"About 1969 I did a couple of pieces. I didn't remember the date until I ran into a guy on the ferry who owned one of them. I asked him to send me a picture of it and the date. I remember him because he was a welder; I liked him so I gave him a carving. It was varnished and had about six colours on it! I guess that was my first real try.

"In 1971, I moved down to Vancouver from Prince Rupert. I was a millwright by then, and I was waiting for a job. The union said if I was going to get any work, I had to be ready for phone calls. So I had to sit by a phone and wait and wait and wait. I only got work on the weekends, because that's when most mechanics and millwrights had their days off. So I started carving again. Before I knew it, people, mostly students, were saying, 'Do you have another one like that?' or 'I want to buy one like that.' I'd say 'Yes,' then rush home and whittle it out. Then I'd come ambling back and say, 'You can have this one.' This went on and on and on until I found out I was making as much money carving as I was as a mechanic. When I was thirty-one, I put my other tools away and started buying store knives, chisels and so on.

"Then in 1973, Port Edward put out a call for bids on a totem pole. During that time I was doing anything—Haida art, Kwakiutl art, I didn't know the difference. I was just carving it and selling it. I'd use books and those twenty-five-cent pamphlets that they sell at museums for ideas. I just copied all that, not knowing the style, not knowing whose work I was copying. When I got the bid at Port Edward, I was frightened. I thought, now everybody is going to see my work, and I don't know what I'm doing.

"About that time, Bill Reid, Bob Davidson and Doug Cranmer were working in the carving shed at the University of British Columbia. Nobody knew who I was in those days, so I sort of hung around and asked here and there, 'Uh, what style are you doing? What style is that?' and 'What is Nisga'a style?' And they said, 'What is Nisga'a?' Later on I visited Bill Holm, a museum curator in Seattle. We looked at his slides of native artwork, and I asked him the same questions. He said he really didn't know how to define Nisga'a style and that it would be a good thing for me to do so. I used the label 'Tsimshian' to describe the style that I wanted to learn about because it included all three—Tsimshian, Gitksan and Nisga'a—in one category.

"I started getting little tips here and there, which I ran home and whittled out right away. From there, I went to museums and started looking up Tsimshian. And sure enough, some pieces were labelled Tsimshian (Nisga'a). Then things started to fall into place. I started doing little models of the pole I wanted to do in Port Edward. When I got my downpayment on that pole, I asked Peter Macnair at the British Columbia Provincial Museum, I think it was, where I should go next for further study in Tsimshian. I had exhausted Victoria. He

said, 'Have you tried Ottawa?' That very weekend, I was in Ottawa. From there on, it was just running from museum to museum.

"That's how I learned. Nobody really sat me down and said, 'This is how they do it.' Nobody said, 'This is what the tools are made of.' I had to take that from museums, too. Being a millwright, I knew something about steel and blades and heating and making edges on chisels and things like that, so that all came in handy. Of course, being alone, I worked hard. The Haida had Bill Reid. The Kwakiutl had Mungo Martin. Gitksan was on its way with the 'Ksan carvers. But there was no Nisga'a.

"The only early Nisga'a carver I know of is Oyai. My mother says that he's a great, great, great-grandfather on the Eagle side. His style is the Eagle-Halibut pole standing in the University of British Columbia's Museum of Anthropology. That's the first one I studied, the only one available to me, and I repaired it for the museum in 1976. So a lot of my stuff comes from that. I've since added more to that style, and I'm still adding to it. I came across still another pole— the 81-foot one at the Royal Ontario Museum in Toronto—that belonged to a great, great, great-grandfather. I don't know who carved it, but I suspect it was Oyai or an apprentice of his. At the time there were several carvers on the Nass River, and my father can't remember them all. He was a very young kid then. He remembers stories of how that tall pole came into being, but he doesn't remember it being carved. He was told by his grandfather, I guess.

"Being labelled a master carver used to mean something. But in more recent times, people started using that term loosely, and it lost its meaning. Carvers who could work only in one or two media started calling themselves master carvers or were referred to as master carvers.

"In my opinion, a master carver ought to be able to design and execute anything—masks, jewellery, flat design, totem poles, canoes, houses. I also think a master carver ought to be able to work in a variety of media—wood, silver, bone, flat design or bark.

"Furthermore, a master carver ought to be experienced enough and knowledgeable enough to be able to carve in a variety of styles, not just the tradition of the place he comes from. He should understand the differences in style and also know how to achieve them.

"That's my definition of a master carver. I haven't mastered everything yet, the way that people did in the old days.

"Carving a pole is probably harder on me than on the crew, because I have the final say. And the people, the elders, will judge me. I have to answer to them. In the actual carving, I'm the one who says 'Yeah, that's right,' or 'No, take that out, that's not the way I want it.' When the pole is up, a lot of eyes will be on me only. People are not going to say, 'Well, it was the apprentices, because Norman

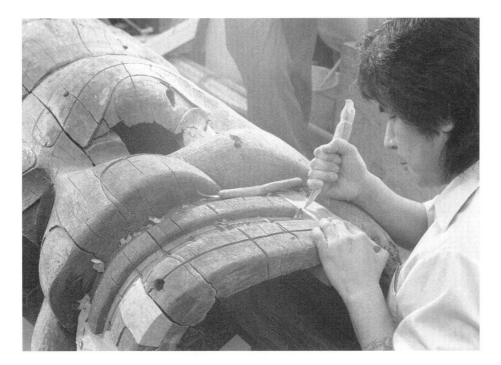

Norman credits the historic Eagle-Halibut pole attributed to Oyai, which he is shown restoring here, for strongly influencing his style. *Photo by Henry Tabbers, Vancouver Museum*

never makes a mistake.' I'll be the one who gets it!

"The end result feels like I've taken out my whole inside and put it on a scale. It's me on one side, the elders on the other. And I have to balance. If they go thumbs down, I go down. If they nod, it's O.K. Even just thinking about it now, I feel a little shaky inside. And yet it's such a thrill to do it, to accept that challenge.

"There's also a lot of pressure from the larger family. They sort of watch you closely, and the pressure is to do it and do it right. 'Make us proud of you.' You're not only doing it for yourself; you're doing it for them. Each family has their priorities, and everybody wants their family to be in the forefront. They sort of hit you with it, with reminders and corrections. But at the same time, they'll defend you when someone else hits you with that same thing.

"Just like my family puts pressure on me, I put more pressure on this group to do their best, because this group is more family. It makes you feel good to know you're not alone, that you're not the only one working on it. And when you're done, you're not the only one celebrating.

"That's the beauty of what's created. I designed the pole; they carved it. It doesn't really matter who did what—the pole is there. We were all in this one building. We all sweated. We all did the whole bit. And in the end we all celebrate.''

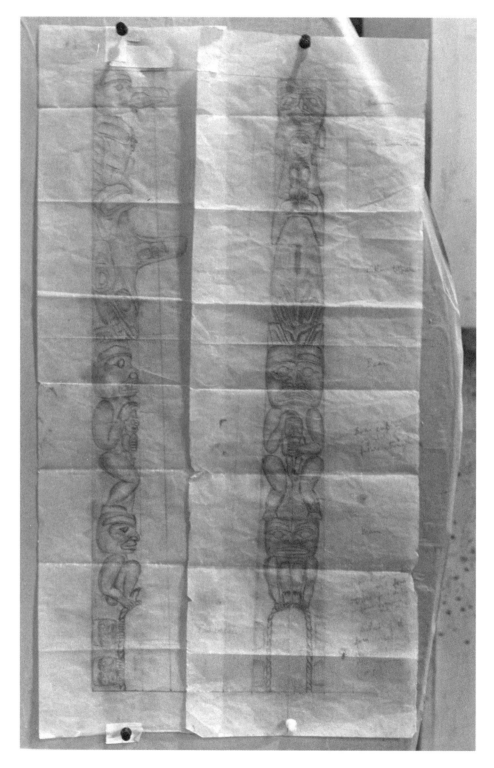

Norman drew these front
and side views for his
submission to the Native
Education Centre.
During the carving
process, the drawings
were regularly consulted
by the crew members.

THE STORY *of the* POLE

The crests or figures on a totem pole generally relate to the identity of the owner of that pole. Often it is assumed that knowledgeable people can ''read'' and understand a totem pole merely by identifying these figures. In fact, the combination of figures serves more as a memory prompt for those who already know the identity and stories of the pole's owner. People who witness the raising of the pole and hear its story proclaimed are expected to remember both the occasion and the narrative whenever they see the pole. And, at least in times past, they would pass on that information to their children and their children's children.

Traditionally, on the northern Northwest Coast, a family of one clan would commission a carver from another clan to carve a totem pole. Such a pole might be one of several types: a house post, a house frontal pole (often including the doorway into the house), a memorial or commemorative pole, a mortuary pole, a grave marker or a welcome figure. The owner of the pole would tell the carver which crests to put on the pole but would usually leave the design of the pole up to the carver. Today, totem poles are commissioned by groups such as the Native Education Centre, museums, shopping malls and large corporations, none of them with traditional family affiliations or crests. So customs and traditions have to be reshaped, and in such instances it has become common for an artist to design the pole around a story belonging to his own lineage or one that he has been given permission to use.

In the case of this totem pole, Norman says, ''The Native Education Centre wanted this pole to represent all Indians. But I told them, 'If you want a universal symbol, don't ask a Northwest Coast carver.' You can't just make up a totem pole

and say, 'This is the prairie part, this is the eastern part,' you know. So I ended up doing a story about the beginning of Man, and this pole is it.''

''The story of the pole starts off when Man was alone on this earth. He was alone for a long while. And you can see Man right at the very bottom of the pole. He wandered the earth and was being taken care of by the spirits.

''Then one day he wondered, 'Why am I alone?' So he went into the forest and spoke to the spirit of the forest and said, 'Why am I alone? Isn't there anyone in this forest who could help me?' And the spirit of the forest said, 'I'll give you Black Bear. And if you learn to live in harmony with him, I will send you more of my children.' He did. And Man learned how to live with the forest people.

''Then he went on. In his travels, he noticed that there was nobody in the water. So he went to the spirit of the water and said, 'Why am I alone on the water?' The spirit of the water came forward and said, 'I will give you one of my children.' And he sent the Blackfish. He said, 'If you learn how to live with the Blackfish, I will send you more.' And Man learned how to live with the Blackfish and the people of the water.

''Then as time went on, Man noticed that there was nothing in the sky. So he said to the sky spirit, 'Send me one of your children. I've already proven twice that I could live with other than myself and my people.' And the sky spirit sent him the Raven. Man proved again that he could live with them.

''The proof that Man could live with the spirit children of the forest, the water and the sky is everywhere around you. You look in the forest, and you will find abundant animals. You look up in the sky, and you will see birds of all sorts. You look into the water, and you will see creatures of all kinds. Man learned how to live with them.

''That was one of the first stories that was passed on. If you want your children to go on living with you, learn how to live with them. If you can live with them, you can live with each other and you can live with yourself. That's the story of the pole.''

For each totem pole that he carves, Norman feels a responsibility to find an appropriate story and to ensure that it is told properly. He explains, ''The elders are going to want to know where I got the story. Mainly they're going to ask me, 'Do you understand the story?' ''

Many of the stories that Norman uses come from his maternal uncle, Rufus Watts, who is affectionately called *ye'e,* or ''grandfather.'' However, the story for the Native Education Centre pole came from Hattie Ferguson, an elderly Tsimshian woman from Kitkatla, whom Norman met when he was just a young carver.

''The lady that gave me the story for this pole really liked me. I first met her

through school, carving. She was far away from home, and I was carving Tsimshian style. There was no one else around here; I had no elders at the time. And I hadn't gone into asking my grandfather 'What should I be doing next?' So she was the only elder, and I used to attend all of her functions, not realizing that she was gradually taking me under her wing. She knew that she was keeping me carving.

"One day she told me a lot of things that she knew, that she had gotten from her grandfather on her mother's side. A lot of them she asked me to keep to myself, but she wanted me to know them because they were educational about 'our people,' as she called them, from the Tsimshian area.

"When it came time for me to carve a pole in Port Edward, she heard about it. I showed her drawings of it, and she said, 'I know a story that was appropriate for that time. The next time that comes up—and it will come up again because that's what you do now—here is the story.' She sat down and told me the story. Then she asked me to tell *her* the story. I told her the story; it was still fresh in my mind. And then she told me the story again, and that was that.

"Then about a year later, I was demonstrating carving at the Vancouver Sea Festival, and out of nowhere, she came up to me and said, 'Do you remember the story I told you?' 'Oh yeah, I remember. It was a good story.' 'O.K.,' she said, 'tell me.' So, I tried, but she walked away shaking her head.

"I thought, 'Oh no. That's it. I don't want to work any more. This is too much.' But a few days later, I phoned her up and said, 'I want to come hear that story again.' And she said, 'I knew you'd come! I just left it up to you to come. If you wanted it bad enough, if you wanted to be a carver, if you wanted those stories, you'd come.'

"So I carved a little spoon, a seaweed spoon—*hoobixim xhlḵ'askw,* we call it— and I inlaid it with abalone. I brought it up and asked her to tell me the story again. Then she cooked Indian food and she told me the story. She asked me to tell it to her, and I told it. She told it to me again. She asked me to tell it to her again. This went on until she was satisfied. Then we ate. But before that, I gave her the spoon. 'This is for you to use,' I said, and she was real happy. It was a real good feeling between the two of us.

"Hattie Ferguson is dead now. But this is how I got the story. And I treasure it."

Once Norman chooses an appropriate story to use on a pole, the next step is the design: figuring out the placement of the figures that are part of that narrative, as well as any crests he wants to incorporate. He explains, "How you go from story to design depends on how the story unfolds. On this pole, I could have put Man on top and then told the story from there. That would make Bear underneath, and then underneath the Bear would be Blackfish (or Killerwhale),

and then underneath Blackfish, another Man to enclose the whole thing—or my crest. My crest being there would claim that it is my story.

"I went through several drawings. And I went through the story. After I did one drawing, I thought, 'If I told the story, would I be able to follow it with this drawing?'" As he asked that question about each sketch, Norman says that the sketch fell apart. "So I went back and tried it again, until I finally got to one that felt right.

"When I started telling the story, that elderly lady was in my mind. She's not here to correct me, so I have to be my own elder. When I use one of my grandfather's stories, I can listen to the tape over and over and over. But with this story, I had to decide alone.

"I simplified the story and added my own signature to it—that's the Wolfcub, which represents my son Micah. The Moon face is also my choice. It's from the Raven story—when Raven stole the Sun and dropped it while he was showing off. It broke into two pieces: the larger one is the Sun, the smaller one the Moon, and the dust that flew away when it smashed is the Stars. I'm somehow drawn to the Moon. Actually, if you ask people that know my style, they'll tell you the whole pole is signed up and down."

CARVING *the* POLE

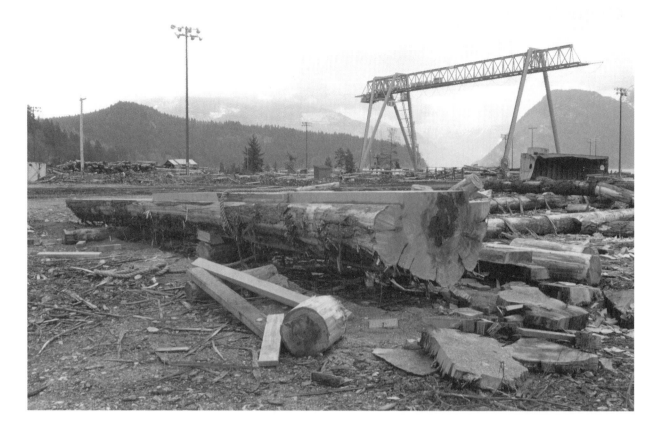

Locating a red cedar tree
suitable for a totem pole
can take months. It must
be of sufficient size,
have straight grain and
minimal wood rot.

CUTTING *the* LOG

28 March

Like many coastal villages in British Columbia, Gibsons Landing relies heavily on logging and fishing for its economy. The L & K log-sorting yard is a few miles out of town, a wide spot bulldozed out of the surrounding trees and bush. One red cedar log is separated out from the great piles of felled and limbed timber. From a distance, this log appears almost ordinary. Closer up, its girth and length dwarf all the others. It has taken weeks to locate a tree that is five feet in diameter at the base and tall enough to carve into a 42-foot totem pole. This log is special, and so is the totem pole it will become.

Norman Tait is very quiet as he approaches the chest-high log. He walks around it several times and finally breaks the silence, angrily.

"Damn, it's cut like a Haida log."

Skirting the log yet again, Norman explains that he wanted only a third sawn off the back of this log, a cut that would leave two thirds of its surface available for carving. But this log has already been cut in half, more in the style of Haida poles. Either he will have to start the search for another log or he will have to redesign his pole, carving the figures shallower than originally planned. Finding another massive red cedar log will not be a quick or easy task, for totem pole carvers require huge, first-growth trees with straight grain and minimal wood rot. The second- or third-growth trees that now make up most commercial harvests are centuries away from the necessary height and circumference. Even though this log is not cut as he intended, Norman is aware that it is a sound, sizable chunk of wood. It is also ready to be worked.

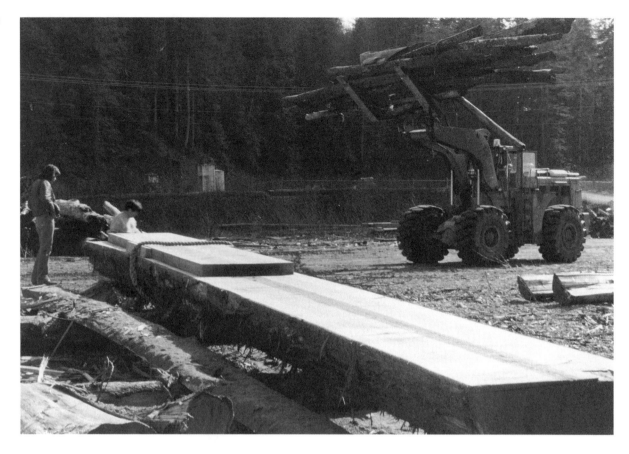

Since this log will become an entrance pole, a slab of wood has been cut on the back of the base to fit into the building's doorway.

Usually a carver chooses where and how deeply to cut the back off a totem log, or he hires someone with experience to do so. As for many of his earlier poles, Norman has had Earl Carter and Kevin Helenius prepare this log. They inspect the log for damage that might have occurred when the tree was felled or transported. Then they "sound" the wood, tapping and listening for a hollow sound that suggests a healthy tree with little or no wood rot. They also note where the bigger limbs are; once cut off, those areas will be major knots and require special care when carving. Norman explains that a solitary tree has limbs occurring on all sides. But a tree this size, competing with others in a forest, usually has more limbs growing in the direction where light is most available. If the side studded with the most limbs is sawn off, the carver will have fewer knots to contend with.

After a final look at the dilemma this log presents, Norman decides to redesign the Native Education Centre pole. Then his thoughts shift to another issue—his crew. He had hoped to get Nisga'a carver Mitchell Morrison or his own brother, Alver Tait, as foreman, but neither was available. So he has chosen

his youngest brother, Robert Tait, or "Chip," to head up the crew. At thirty-one, Chip has carved totem poles before, most notably helping Norman with the 55-foot Big Beaver pole for the Field Museum of Natural History in Chicago, but this is the first time he will serve as foreman. To mark this new status, Norman gives Chip the drum he received from the Native Education Centre upon signing the contract for the totem pole.

The other two crew members are young apprentices. One of them, Norman's twenty-six-year-old nephew, Wayne Young, is talented at drawing and sculpting. Although he has only dabbled in Northwest Coast art, family members feel Wayne has potential and have encouraged him to get into carving seriously. The other apprentice is Norman's nineteen-year-old son, Isaac Tait, who has already carved a few small bowls and a spoon, but this pole will be his first. Known as "Ikey" to some of the older members of his extended family, he received his first set of tools when he was thirteen and produced a halibut bowl after watching his father teach his uncles and others how to carve a bowl. Both the apprentices have proven their interest by being around, willing to help without being asked, when other carving projects were underway. Wayne is Chip's choice for the crew, and Norman wants his son on this project.

The centuries-old native tradition of family carving seems right and comfortable to Norman, but he is concerned that this crew may be too small and not experienced enough to carve a totem pole with a delivery deadline just three months away.

Noticing Norman's presence in the log-sorting yard, the forklift operator motors over and asks, "Do you want it forked?"

Norman declines the offer to turn the log, explaining, "It will have to be flipped before we start carving, but first we're going to put a chainsaw cut right through its back to relieve the tension."

Chip calls this process "putting in the trough" or "taking out the back"; others call it "coving" or "hollowing the log." He explains, "Mainly, the first thing you do is take the back off the log and put the trough in. That eliminates all the really tight, pressurized wood in the centre. It also helps the back dry evenly, as fast as the front. Red cedar is a splitting wood. It splits cleanly. It will split by itself if you let it, so the thing is to avoid cracks or slow them down by taking out the back of the log. Then the pole will have only minor 'checks' or splits. The carved wood will just open and close, open and close a little bit, because it does that in the back, too."

The yardman is concerned that cutting the back might weaken the log so that it will split in half while being turned over. Norman reassures him. "That's my responsibility. Just drop it quietly and slowly."

As Norman heads out of the sorting yard, he stops to examine a slab that has

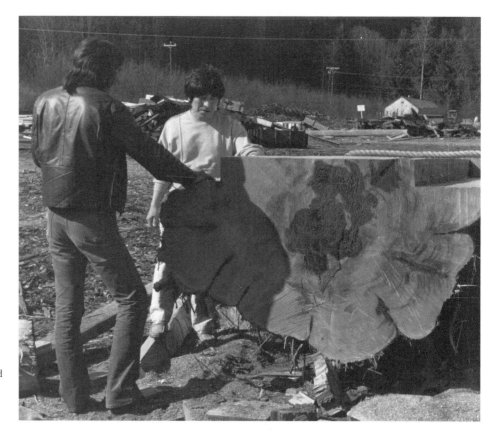

Even cut in half, this totem log is massive. The deep flares at the base will be cut away and the log evened from top to bottom.

been sliced off the butt end of his massive red cedar log. Counting the rings, he estimates this ancient tree had been growing for five hundred years—half a millennium. It was already centuries old when the first European explorers sighted the Northwest Coast.

29 March to 8 April
In the L & K sorting yard, the log has been turned onto its flat back, so that the rounded part is accessible to the carvers. In a week or so it will be transported to Vancouver, but Norman wants his crew to begin work on it right away. So Chip Tait and Wayne Young come by bus and ferry from Vancouver to Gibsons Landing; Isaac Tait hastily flies down from Prince Rupert and joins them a day later. Working outside in the spring rain, they start removing the bark and taking off the first layer of wood.

"I like to try and eliminate most of the backbreaking work," Chip explains, "so I look at the log first and study it, study it. I see where there might be a bump, a lump. That lump might have to come off anyway. I check all the scars and check the breaks where the log's been cracked by the fall or by a boat when

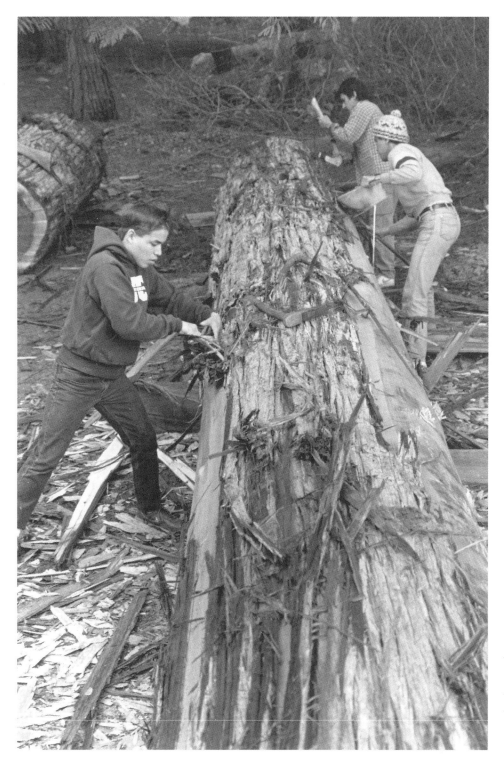

After the trough is cut into the flat back of the log, the pole is rolled over and the bark removed with adzes, axes and muscle.

being towed or whatever. I see where the bark is sagging, where it's been rubbed and pulled and dropped. That's a starting point. It's like when you're peeling an orange and you find that little niche; you put your thumb in it and then go. Well, it's the same thing taking the bark off a log.

"Then you can see where the sapwood is and test to see how deep it is. That sapwood or 'white' wood is just underneath the bark," Chip states, referring to the outer layer of wood that must be taken off in order to get to the red cedar core underneath. "It's all part of learning to read the wood. It's what helps you know what you can cut into and not damage the roundness, the front of the pole."

Although he is experienced and confident about his own work habits, Chip is very aware that he is working as foreman for the first time. "I already knew how to work for Norman, but I was just learning to be in charge. I still think the reason I got to be foreman on this job is not because of my carving experience, but because I remember details and stay on them. My work habits are strong and I've stuck with that."

Carving is also a familiar part of life for Norman's son Isaac, but this is his first time on the payroll. "My father has been carving heavily since 1971 or '72. I'd come home from school, and see my mom sewing a button blanket and he's carving. I'd wake up in the morning and water down the pole and look at it. Dad does the ceremonies and so on. To me it's all a part of life. That's what he does, and that's what I want to do.

"I was in Prince Rupert at the time this pole got started. I had no idea what was going on until I got this phone call from my mom to phone my father right away. He told me about it, and I said, 'Sure! I'll be there.'"

Wayne is less familiar with carving and native traditions as a way of life. He describes himself as having "been on the road," travelling as far as San Francisco; now he is married and living in Vancouver. "I've been just wandering around for the last little while, and I've been missing out on a lot of stuff. Now I'm getting involved. I think it's great, but it's a lot of hard work!"

These first few days prove to be a gruelling initiation for the two young apprentices, as Chip teaches them how to use the heavy two-handed adzes necessary for this type of rough work. Isaac recalls, "We all referred to Gibsons as 'crawling in the mudhole' because it was raining and we didn't have our rain gear. We were swearing away, adzing away, getting all sore because we weren't used to such heavy work."

At the end of each long, wet day, they cannot afford the luxury of a restaurant, so Chip has to push them to cook dinner in their motel room and make sandwiches for tomorrow's lunch.

Wayne states frankly, "I had a feeling it would be hard, especially at the beginning of the pole when the really tough labour had to be done. But I still

wasn't ready for it. I'd never been through any experience like that.''

Isaac has an elbow adze of his own already, but Wayne has to borrow one from Chip in order to start work. By doing so, Wayne puts himself in debt to his foreman, and according to Nisga'a tradition, he must repay that obligation, even if it is only an acknowledgement at the pole-raising ceremonies. Chip's primary interest is getting his adze back in good shape. Unfortunately, Wayne breaks it on one of his first chops.

When a tool such as an adze breaks, it can be for a number of reasons. It may be poorly made, the wood or metal it is made of may be of inferior quality, or the tool may have been improperly used. ''In Wayne's case, he used it wrong,'' Chip explains. ''He had a lot of power behind it; he stuck that adze deep in the wood and pulled on it. So it just snapped off.''

Chip recalls a similar incident. ''Years ago my nephew Ron Telek made a brand-new adze, and he was real proud of it. Norman wanted to go get some adze handles, so we all went into the bush. I said to Ron, 'Let me try your new adze.' I hit a knot, and it snapped. You should have seen his face drop. He didn't even get a chance to use it.''

In order to fetch more tools and equipment, Chip has to leave his two apprentices working on their own for a day while he makes a trip to Vancouver, returning on the late ferry. Both he and his crew look forward to finishing up this first week of heavy work. Then the log will be moved to Richmond, a suburb of Vancouver and a much more convenient location. Chip is also eager to have the two apprentices get started on making themselves a complete set of tools.

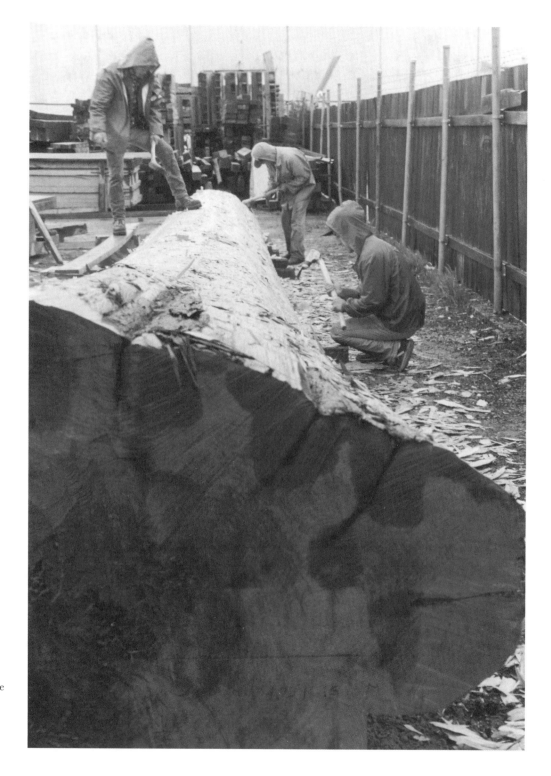

Now the heavy labour begins. Standing, kneeling, seated or crawling atop the log, the carvers adze the pole to make it uniformly smooth and round.

ROUNDING *the* LOG

10 April

Over the past two days, the massive cedar log has been trucked and ferried from Gibsons Landing to Richmond. It rests off to one side of Turnbull and Gale's construction yard, the contractor that is building the Native Education Centre in Vancouver.

Chip describes the three stages in the carving of a totem pole. "First is roughing the *log*. That means putting the back in and getting the bark off, the bumps out, getting the centre lines on. Then we finish the log and it's ready to be a pole—not a totem pole, just a pole. Sometimes we call this first stage 'rounding' or 'smoothing' the log."

Then comes the second phase, roughing the *pole*. "That's getting the figures cut. Initially the chainsaw can be used instead of axes or bigger adzes to get down into the pole fast." The chainsaw is a quick way to get backbreaking work done when there is a lot of wood to be taken out, but adzes, chisels and mallets are used for the bulk of the work. This second stage is the longest and includes the rounding of the figures.

The third and final stage is finishing the pole. "This is when you put the machines and the heavy adzes away and bring out your fine adzes and your curved knives. All the figures have been cut and sculpted, so this third stage involves finer work, primarily on features, and cleaning the surface."

Progress on the carving of a pole does not adhere rigidly to these stages, however. In actual practice, one portion or figure is often worked on ahead as an example, or one section may lag behind the rest of the pole for a while.

The crew is now well into the first stage of rounding the log. The bark has been removed, a shallow trough has been cut in the back, and the sapwood is being taken off. The constant rhythm of three adzes biting into the wood is muted by falling rain. "Chunk, chunk, chunk, chunk." (Pause.) "Chunk, chunk, chunk, chunk." (Pause.) "Chunk, chunk, chunk, chunk."

From time to time the apprentices flex their shoulders to relieve cramped muscles. Wayne Young's blisters are bleeding, but the work goes on. If there's a break, it's to add another Band-aid or sharpen an adze. By midafternoon, the crew members wear their tiredness like a heavy blanket.

The first measurement that a crew usually makes on a totem pole log is to mark a centre line on the cleaned carving surface. This pole, however, will have a doorway cut through it, so the centre line was marked on the back when the back of the log was cut off in Gibsons Landing. This was necessary in order to measure and cut a slab at the base of the log that would fit exactly into the front doorway opening of the building. Now Chip simply transfers the centre line measurement from the back to the front, snapping a chalk line that stretches from one end of the log to the other. Whenever this centre line is adzed off in the course of the day's work, it is immediately redrawn.

The next step is putting on the side measurements. Establishing them must take into consideration the fact that on this log the base flares out more on one side than the other. Chip wants to keep as much width for carving as possible, but is restricted by the narrowest flare. So he measures it and then marks off that same distance on the other wider side.

Chip has two overriding concerns. "Right now my job is to get the log evened out and to teach these guys a respect for the wood." He passes on the knowledge he has gained from working with Norman, cautioning Wayne and Isaac to keep moving as they work. "I'm telling you not to go down so deep in one spot with your adze. This log has to go down uniformly. Move up and down the pole. It's like rounding a dowel; you don't do one inch first and then the next inch. Just make sure you have your guidelines and then do the whole thing."

The 7 A.M. opening and 5 P.M. closing of the construction yard gates set strict limits on the hours that the carvers can work. Norman is pushing to get the log cleaned so that the actual carving can begin. He and Chip discuss moving the log to a more convenient location, where the crew can also work nights.

11 April

Payday is still two weeks away. The apprentices are sore and tired, but Chip lectures them that eight hours of adzing is only half their job; they also need to finish making their heavy adzes and sketch a crest design for the regalia they will wear at the pole-raising ceremony. "Right now there is no time for socializ-

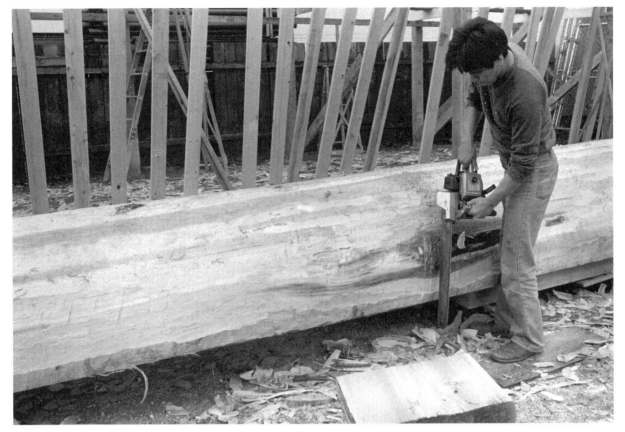

ing, no time for outside work,'' he states. For a while only the adzes speak.

''The hardest part of it all must be taking orders,'' Wayne comments. ''I've been just freewheeling for years now, travelling around, doing just whatever I want. And it's kind of hard for me to buckle down all of a sudden and just throw myself into it, to dedicate myself. Actually, I didn't take anything seriously at the beginning until I realized how much Chip knew and how valuable it was. That's when I really started absorbing everything. Another thing that got in the way was being resentful of him, you know, for screaming down our throats. He'd say, 'Norman's going to come down on me and I'm going to come down on you, you got that?!''' He pauses, then adds, ''But I think it's going to work out, and that keeps me going.''

Chip purposely ignores the tension, then fires up the long-bladed chainsaw and calls the apprentices over while he demonstrates how to cut around knots in the wood. ''The wood around a knot runs in all kinds of directions. In this case, the knot grows out, so the wood grows out around it. If you hit it with your adze in the wrong place, it'll pop off. Then you've made a big hole. So

As Chip chainsaws, he cautions, ''The wood around a knot runs in all kinds of directions. You have to read the way the wood goes and test it.''

you have to read the way the wood goes and test it. If your adze digs in, you turn and go the other way. In some cases you have to go straight across the knot. You can also cut it with a saw. It just takes time and it takes patience. What you're trying to do is not ruin the wood and not break your adze. You're fighting with this knot, and sometimes you think the knot's going to win! But you're going to beat it. It just takes a long time.''

The apprentices return to their adzing. Chip watches for a while, then announces, ''Let's go for coffee.'' The three carvers head for a small café down the road. When steaming mugs of coffee and hot chocolate are in hand, Chip begins outlining the plan to move the log to the carving shed at the University of British Columbia's Museum of Anthropology. The massive log will be trucked to the university, but it will have to be carried by hand into the carving shed, a heavy job that will require a lot of people. ''We've got to get at least twenty guys apiece to move it. I mean it! We've got three days to round up a hundred people to carry the pole into that shed on Monday. Then on Tuesday, you guys have got to have your new adzes ready. No more fooling around about that.''

The lecture over, he tells the two apprentices, ''There's no place I'd rather be than on this project, but it's quite a contrast to when I first started out and had Norman to teach me. I used to be late, horse around, get tired real easily and be cranky. He tore me right down in front of everybody. He said, 'Smarten up, boy, or pack your bags.' I knew he meant it. I'm his brother, but that doesn't mean a thing when it comes to his work—*my* work, now.''

12 April

The newly adzed cedar log gleams white in the spring sun. Chip gives it another of his frequent visual appraisals. ''It's starting to look like a round pole now.''

Isaac steps back to see for himself, then grins his approval.

''Keep eyeing it, keep checking it,'' Chip reminds the apprentices. ''Don't wait for me to tell you.''

Working on the butt end of the log, Chip alternately uses chainsaw and adze to trim down the thickest flare of wood. Then Isaac takes a turn. Slowly the base evens out in line with the rest of the pole.

Chip moves on to measuring and marking the doorway that will be cut through the base of the pole. He checks the levelling lines on both ends of the log, then calls Isaac. ''We've already levelled the log, but I want *you* to check it. Don't take my word for it.'' Chip demonstrates the levelling procedure on one end of the pole, then has Isaac teach the same thing to Wayne at the other end. After both ends are checked, Chip gets out the chalk line and carefully snaps a new blue centre line down the entire length of the pole. Then he marks the two-foot by six-foot dimensions of the doorway at the base. Unable to resist, Chip climbs

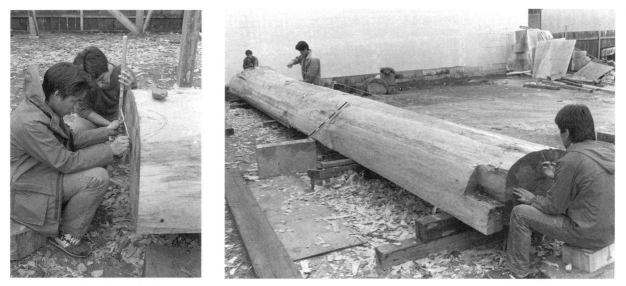

up onto the log, lies down and stretches out in the doorway. He fits!

"I'm going to start cutting the door to make the log lighter to carry," Chip tells the apprentices. The chainsaw roars into action, its blade slicing two-inch-deep parallel lines across the doorway's pencilled outline. He cuts the motor and picks up his double-bladed axe. With each stroke, cedar chips fly. When the hole is cleared to the depth of the first saw cuts, he repeats the cut-and-chop procedure until the doorway rectangle is 12 inches deep, clean and definite.

While his crew handles the heavy labour of rounding the log, Norman has been redesigning the pole as well as working on other projects. But he and Chip regularly keep in touch by phone. Norman explains, "I'd ask Chip, 'What happened today? Give me a rundown.' He'd give me a report, and then we'd outline the next day's work. But I also kept track of how Chip was doing as foreman by calling the apprentices to get their point of view.''

As head carver, Norman Tait has to balance the demands of this large project with other work, relying heavily on the support and assistance of those close to him. Administrative jobs such as paying bills, writing grant reports or dealing with requests and correspondence fall to Reva Robinson, Norman's companion. Hope Tait, one of Norman's sisters, will shoulder the responsibility for getting the crew's regalia completed. Norman's mother, Sadie Tait, will supply much of the guidance and energy for the ceremony to accompany the pole's raising. When he has questions regarding Nisga'a tradition, Norman often phones Mercy Robinson Thomas, a high-ranking Wolf clan chief.

The competence and assistance of those close to him allow Norman time to work on his art, travel to study pieces in museum collections, attend to family

Left:
Even though he has already levelled the log, Chip has Isaac repeat the procedure and then teach it to Wayne.

Right:
Chip snaps a centre line on the log. The top corner, where a damaged portion was cut out, will be filled with a wood plug prior to carving.

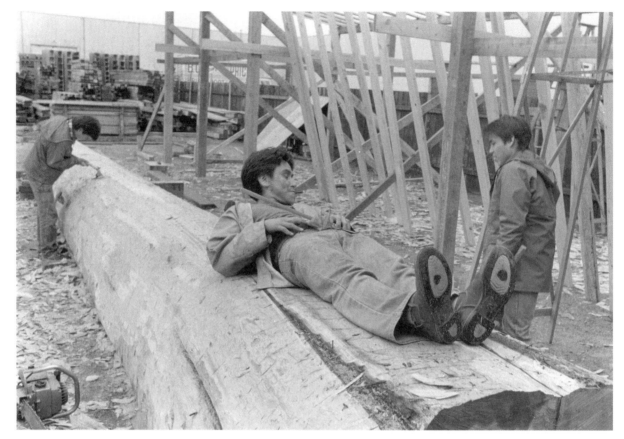

A two-foot by six-foot doorway outline is measured and marked onto the base of the pole. Chip tries it out for size—he fits!

and Nisga'a commitments and make contacts for future work. When everyone carries the weight of his or her job, there is a feeling of energy and optimism. At other times, when Norman is absent too long, resentment and tension prevail.

Over the next ten weeks, Norman will draw the design on the log, make the major cuts, teach his crew about Northwest Coast and Nisga'a carving styles, insure that they know the story of the pole, keep an eye on the progress and emotional temperature of the carvers, come down heavily on his foreman when pace or attitude slips, and direct practice for the singing and dancing that will be part of the pole-raising ceremonies. He will also carve.

Right now, both apprentices and foreman feel a nervous anticipation as Norman arrives on site to check their progress. He eyes the log from all angles, listening to Chip's commentary about straightening and rounding the log. When Norman finally smiles his approval, the crew is elated.

Checking progress on the log is not the only thing on Norman's mind, however. He expects his carvers to design and produce button blankets with the help of their families. A statement of Nisga'a identity, this regalia is proudly worn at

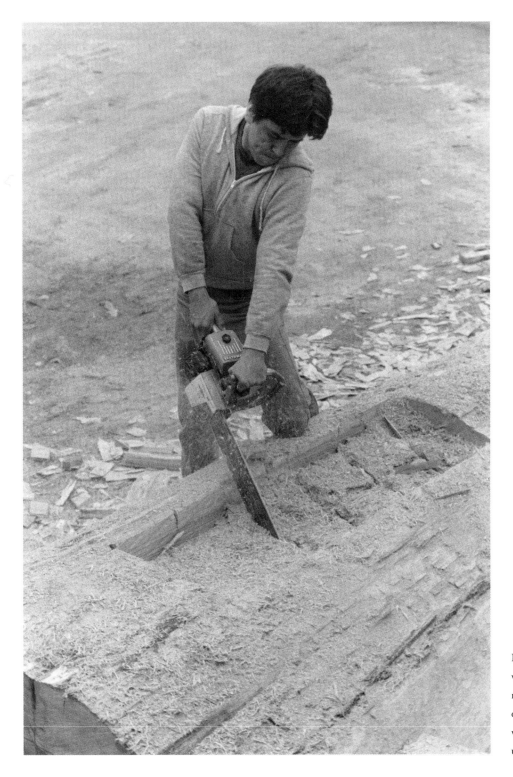

In order to lessen the weight of the log before moving it, Chip begins cutting out some of the wood in the doorway, using chainsaw and axe.

ceremonial occasions such as totem pole–raisings. Because the crest designs are central to the long process of making such a blanket, Norman pushes his carvers to complete a drawing of their clan crests. And now he wants to see their finished work.

There is a guilty silence as rough sketches are pulled from the bottoms of pockets and knapsacks. Although Norman understands the more urgent demands of carving the pole and making tools, he also makes it clear that he is not interested in excuses. Instead, he looks at each rough sketch, makes corrections and pencils some suggestions onto a section of the freshly adzed pole. Norman then reminds the apprentices that the crests cannot be cut out of the red worsted wool, sewn into the centre of the blanket and finally outlined with hundreds of buttons until the design sketches are finalized. He also adds that part of their first paycheque will have to go to the family women who are sewing these button blankets so that they can purchase the material.

Most of this is new to Wayne. It is more familiar to Isaac. His mother, Jessie, has sewn button blankets, and he has watched other family members participate in Nisga'a ceremonies, robed in their regalia. But neither apprentice has his own button blanket.

Norman explains that a totem pole cannot be raised without ceremonies to welcome it and name it, as well as payment to those who witness the event. So carving a totem pole also carries the responsibility for each member of the crew to have his own button blanket, and to learn Nisga'a songs and dances. He fetches his own button blanket from the car to demonstrate the size, proportion and position of the crest design. He drapes it over his shoulders, and the apprentices begin to understand why the regalia is an essential part of the process, part of their own identity as Nisga'a and as carvers. When the next work break comes, Isaac and Wayne spend it with their sketchbooks.

Sensing the undercurrent of tension in the crew, Norman acknowledges, "You guys' schedules are pretty full, eh? You have to do your design, and you have to practice drumming, and you've got to carve."

Isaac answers his father, "All in a day's work, eh?"

Norman confirms, "Yeah, all in a day's work."

"Is that how they did it in the olden days?" Isaac asks.

His father comments, "In the olden days, carvers were taught when they were young."

13 April

If the log demands attention, so do Wayne's personal problems. His marriage is breaking up, and one day he does not show up for work. Chip can easily empathize with the situation, having divorced from his first wife and young daughter,

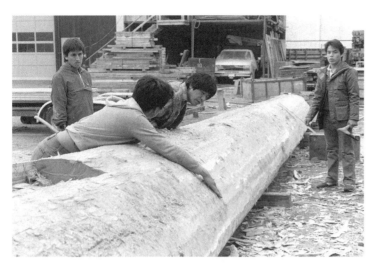

Arriving on site, Norman assesses the crew's progress on straightening and rounding the log.

Norman also critiques the Frog crest design Isaac hopes to use on his regalia.

To inspire the crew in designing their regalia, Norman displays his own button blanket.

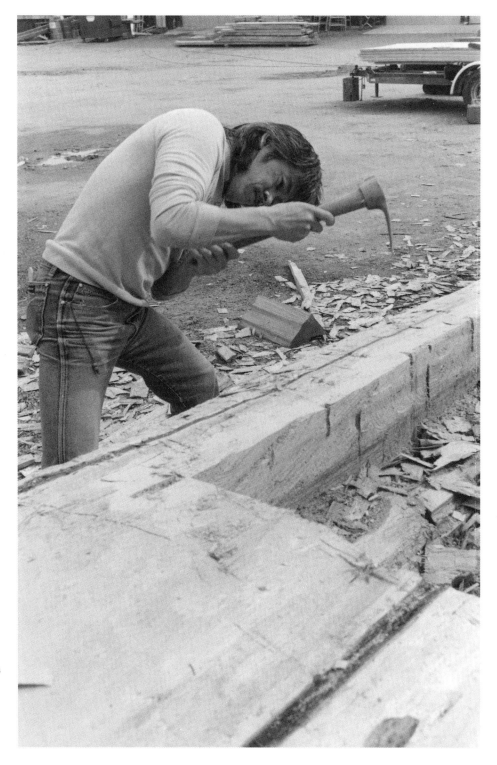

Hammy begins work with a timber adze. Later, he makes himself a native-style adze with its blade set at a narrower angle.

Nellie. "I lost my family because of different things that happen when I'm carving—lifestyle, for one, and pressure. People say I handle pressure pretty well, but they don't see me when I'm really having a hard time. I draw on my family, and in some circumstances, they couldn't take it. I lost my immediate family. I'm lucky I've got my big family to help me. Just to talk to them, be around them, I feel much better."

Norman asks Chip to find someone to fill in, just in case Wayne does not return. Chip puts out an emergency call to Harry Martin, who joins the crew. "Hammy" is Nisga'a and a member of the Wolf clan; he is also a cousin through his mother's side and has carved one small pole with Chip before. But the young foreman has his own reasons for asking Hammy to join the crew. "When I was growing up, my brothers were already gone and my dad was not able to show me the things a man should know. Hammy was older than me, and my mother suggested I talk to him. He showed me a few things—he took me on a boat, showed me how to use a gun—that kind of thing. So I figured it was time to maybe, you know, return it."

Although Hammy has not done much carving, he has been interested in it for a long time. He recalls watching Reginald Wright, an old carver from Stikine village on the Nass River. "When I was little, I was really curious. I used to peek in his window all the time to see what he was working on. He must have noticed, because one day he caught me and invited me in. It was the same with Pat McKay in Port Edward. He was carving miniature totem poles, and I was so eager to watch."

At thirty-seven, Hammy is the oldest member of the crew after Norman and brings to the project his experience and competence with machinery. Starting two weeks into the project poses a difficulty with wages if Wayne returns, since the other crew members have already signed contracts for a fixed percentage of the total cost of the pole. Norman hopes to resolve the issue of salary later. Right now he desperately needs another full-time carver.

"I'd never carved with Norman before," Hammy says. "Chip and I did a small totem pole last year. He was teaching me. At first I couldn't understand what he was talking about—roundness and lines—so he'd draw it on a piece of paper for me. Then I'd go home and think about it, and I'd understand what he meant. So when I started on this pole, I knew what Chip was talking about."

Hammy has known about the project for a couple of weeks. "Chip told me they were going to Gibsons to clean the pole, and I mentioned he could borrow my chainsaw. He said that would be great and asked me if I wanted to come out. He told me I wouldn't get paid. 'That's O.K.,' I said, but then I didn't make it out to Gibsons. When they moved the pole to Richmond, Wayne didn't show up one day. Chip called and said, 'I need you really bad,' so I got my stuff

together and went out.''

"I remember the first totem pole Norman did was at Port Edward," Hammy recalls. "My whole family knew him from a long time ago; we're related, and they used to live next door. When I first saw a thing in the newspaper about that pole, I cut it out right away and kept it. I've got scrapbooks on Norman from way back."

Chip pushes his crew to finish rounding and straightening the log. He knows that once it is moved to the carving shed at the University of British Columbia tomorrow, Norman expects to start drawing on the log. There is little talk. The constant chopping of adzes fills the air, mixing with the pungent smell of cedar.

When the crew finally takes a break, Chip outlines the moving procedure. The rounded log could be moved easily by machinery, but Norman feels strongly that it should be handled as much as possible by hand, despite the extra time and work in assembling manpower.

"We want to move this pole and we're going to move it," Chip states, "but we've got to get at least twenty guys apiece. Every two feet of the pole, there's going to be a crosspiece. You figure three guys on a side, six total; and on the butt end, especially, the crosspieces need to be closer." Chip pauses to let the idea of twenty guys apiece sink in. "I mean it—if you come up with fifteen, you've got to get five more from somewhere. Tell them we'll need them for three hours. We're shooting for a hundred people tomorrow morning."

15 April

Early Monday morning, Wayne rejoins Norman, Chip, Isaac and Hammy at the Turnbull and Gale construction yard in Richmond. Chip has been up most of the night, first phoning to line up people to help move the pole and then sleepless with worry that there might not be enough.

Now that the bark and first layer of sapwood have been adzed off, the crew is especially concerned that the pole not get damaged or marked. They keep checking to make sure that the tongs of the forklift are not biting into the wood. Fortunately, Hammy is experienced at running a small forklift. He joins forces with the construction worker driving a second machine, and together they load the pole onto the waiting flatbed truck. The smooth, 42-foot log is then covered with padding before the securing straps are tightened. Crosspieces for lifting the pole off the truck are loaded, along with end-cuts from the log. Immediately, the crew members head for their own transportation. They have to get to the carving shed ahead of the pole to organize the people they hope are waiting there.

"Pole carriers this way" announces a temporary sign tacked onto one gate on the university campus. There is a modest crowd, mostly native faces, and Chip worries there are not enough people. He explains to the group how the pole will

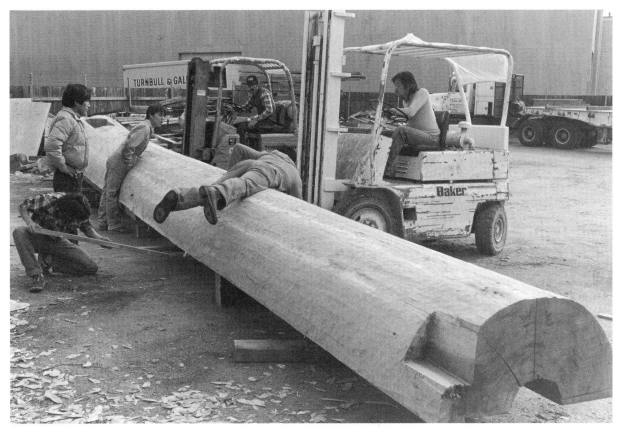

be moved. When the truck arrives, people climb up onto the flatbed trailer as directed and space themselves around the log. But there just are not enough volunteers to lift the weight of the massive pole and manoeuvre it down off the flatbed. It takes the skilful assistance of a heavy-duty forklift to get the pole off the truck and set down on blocks. Once that is accomplished, the job is again in human hands. Long crosspieces are positioned under the pole, extending out far enough to accommodate two or three carriers on each side.

Chip beats on a drum to get everyone's attention. He reminds people how to lift, cautioning against strained backs and pinched fingers. He also explains that the cadence of the drum will signal when to lift, so that everyone works in unison. Backs bend as the drum beat increases in tempo. At the final loud ''boom,'' there is a collective groan and lift. The first attempt is proof enough that this is going to be hard work.

Moving the pole along the road is easy, however, compared to trying to fit pole, crosspieces and people through the narrow spaces between the trees in front of the carving shed. The pole progresses only a few feet at a time, with the

Wayne rejoins the crew as they prepare to move the 42-foot log to a new carving location, taking care not to mark or damage the wood.

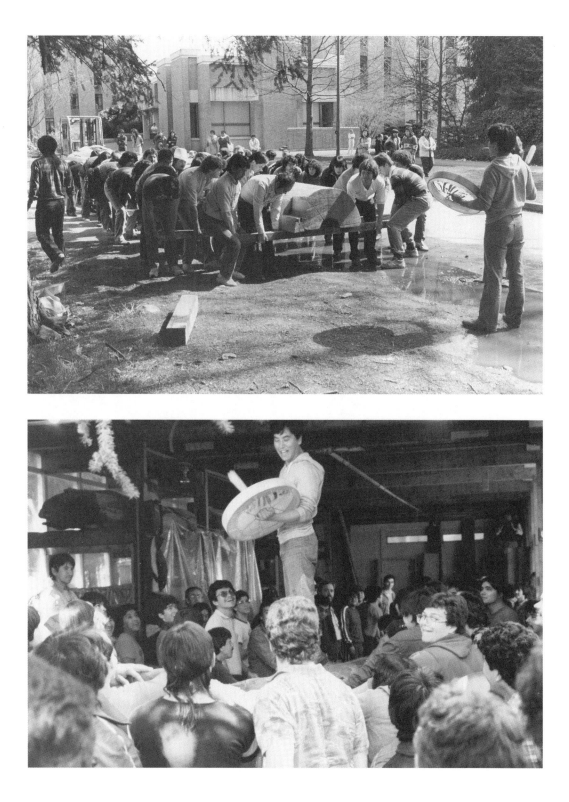

supports being hustled along.

Eventually, the pole is inched into the shelter of the carving shed, and a brief ceremony to mark the move begins. Joe David, a well known Nuu-chah-nulth artist and Norman's close friend, sings a song to honour the occasion. Norman has put on his ceremonial dance apron to make a formal acknowledgement: "We'd like to thank everyone who came to honour this pole, to give it life."

Mercy Robinson Thomas follows with an announcement: "Ladies and gentlemen, we have a tradition that cannot be overlooked. It is our custom for those who assist or touch the pole to help the carvers. Originally this would have meant feeding them, but now this involvement has been replaced with a donation. The Nisga'a and the Eagle clan have a volunteer who will be collecting money to pay for some of the moving expenses." As people line up to put their donations into a cedarbark hat, she begins calling out their names and the amounts of their donations. "Ten dollars, Stan Thomas. Two dollars, Grace Allen. Twenty dollars, Martha Aspinall." The carvers circulate through the crowd, handing out apples and oranges to those who have helped. Andy Morrison, another Nisga'a, counts the money. Mercy announces a total of $126.05 and thanks everyone, formally ending the ceremony.

Elated and relieved, Chip jumps up onto the rounded log, still holding the drum. "I'd like to say thank you very much for my family, for myself especially. To have people like you work for us to do this and take orders from *me* . . . " The crowd laughs. Then, as people begin to leave, Chip calls out a last comment. "Thank you all again for coming. We'll give you a call when we do it for the real thing."

Someone adds, "Hopefully it will be lighter next time!"

Once the log is offloaded from the flatbed truck, Chip uses drumbeats to signal the carriers to lift in unison.

The pole carriers, crew and foreman are elated when the pole is safely inside the carving shed.

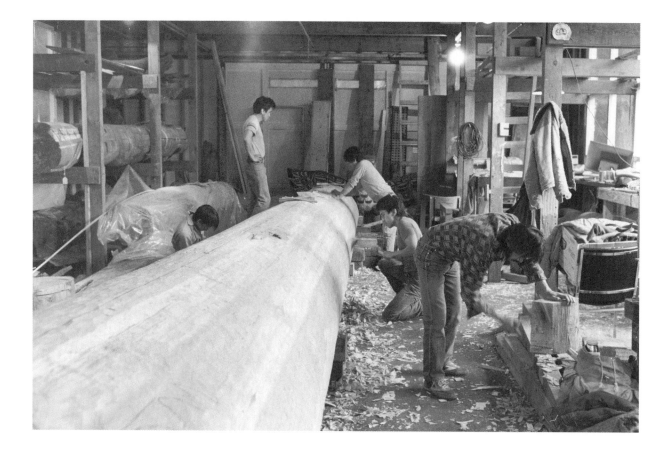

Settling into the carving
shed, the apprentices
continue rounding the
pole while Hammy
shapes a cedar plug.
Chip and Norman begin
laying out figures.

DRAWING *the* DESIGN *on the* POLE

16 April

The next morning the entire crew is together and pleased with their new location. The carving shed, a long garagelike building, is private and far more suitable than the construction yard. Best of all, they can work late into the night. The log waits in the centre of the shed, positioned waist-high on blocks. Plastic-wrapped vintage totem poles that belong to the nearby Museum of Anthropology are stored in tiers off to one side. Drawings and posters left by previous carvers are tacked up all over, with the occasional ovoid or Northwest Coast creature pencilled directly onto the walls. A Kwakwaka'wakw-style carved Eagle keeps a watchful eye from the wall near the top end of the log. On the other side of the shed, there is a standup desk with a phone, and there are electrical outlets for a coffeepot and tapedeck/radio. The bathroom is permanently out of order.

Three naked light bulbs dangle from the rafters, directly over the log. During the day, that illumination is supplemented by natural light filtering in through a bank of windows that lines one side of the shed. On really warm days, wide double doors at one end of the carving shed can be opened. While the fringe of trees and scrub brush does not screen out the nearby university dormitories entirely, there is a sense of privacy and being in the woods.

The apprentices continue their business of adzing the log round. One of them remarks that a section of the log is turning grey. Chip tells him not to worry. Any pockets of sapwood that still remain will get cut away during the actual carving of the pole. They work around a few low spots on the pole that are marked with the letters DNT, for "Do Not Touch." Chip feels that one side of the pole

A vintage Eagle keeps an eye on Hammy as he works at plugging the damaged corner of the pole.

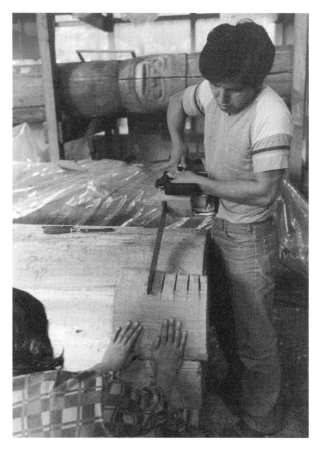

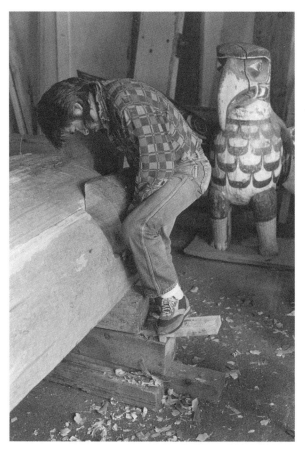

Mindful of Hammy's fingers, Chip uses a small chainsaw to cut the plug down to size.

is still flared too much and needs to be taken down even more.

Norman directs his foreman to get someone busy plugging the top corner of the pole where a damaged area was cut out. So Hammy locates the cutoff butt end of the log that was also brought over from Gibsons Landing and chainsaws out an oversize chunk, cutting a sharp right angle. Using a chisel, he straightens the ninety-degree cut. Chip takes over the chainsaw, showing Hammy how to fit the angle and then how to cut down the outside of the block to match the rest of the pole.

''There was a big, deep fracture right where we needed the head at the top of the pole,'' Chip says, explaining about the area to be plugged. ''It looked like when the tree fell down, it hit a big stump, or maybe if it was towed in the water, it got bulldozed by a boat. We didn't want to lose that extra eight inches by cutting the entire slice off, and it was right where we needed to carve, so that break had to come out and we had to put a plug in there.

''What I learned from doing other poles is that part of training a crew is teaching them how to do repair work, how to do a plug. It has to fit properly so that once all the wood shrinks, there are no gaps; the plug is tight. And it has to blend with the rest of the log.'' The plug is anchored with a combination of dowelling pegs and glue. In short order the repair job is completed and the entire top of the pole is sound.

When the log is clean and ready to draw on, Norman directs Chip to get the crew started on making a map of the log on paper, a procedure he utilizes to ensure that the carvers really know the wood they will be carving. ''Tell them, 'Get your tape out, measure the pole, then mark the knots, cracks, rot—everything that would show up on the finished product or that would be a consideration in carving. Find out exactly where it is on this log and put it down on the paper.' Then when I come in, we know where everything to deal with is.''

Norman is eager to begin drawing on the wood and measures out the lengths he wants for various figures. Referring to the front-and side-view drawings that were his original submission to the Native Education Centre, he checks proportions and begins sketching a rough approximation of the top Raven figure. Next, he positions the round Moon figure that he has drawn inset in the Raven's belly and cradled between its two great wings. As he works his way down the pole, Norman crawls on and over it, armed with tape measure and grease marking pencil. His tracing-paper drawings show that the Killerwhale figure is next, with its flipped tail flukes and a large dorsal fin protruding from the pole. Then comes a large Bear figure, cradling a small baby Wolfcub. The Bear rests on a crouching Human figure which, in turn, grasps a cedar bark rope. This rope encircles the doorway at the base of the pole, with four small human faces around the opening.

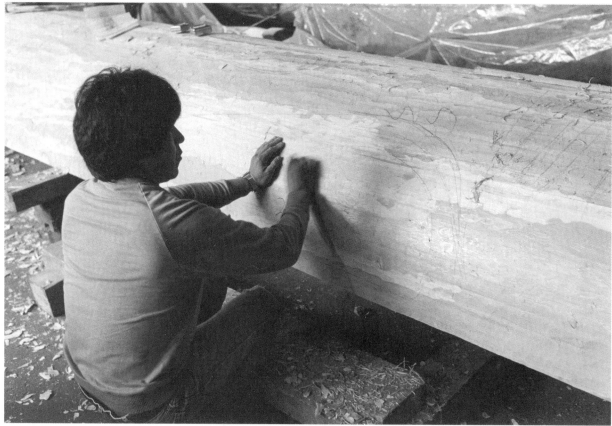

Once the figures are
measured out, Norman
roughly sketches them on
the pole. Here he works
on the Raven's wings.

Norman works with concentrated intensity. Chip is particularly interested in
this transition of going from the drawing to designing on wood, and he keeps
reminding his crew to use their eyes and watch *how* Norman draws on the pole.

Norman directs his brother to begin measuring out the Killerwhale. "These
measurements are very rough, and some move up or down as the days go by,"
Chip states. "Norman says the Whale can move a lot because it is a Whale. You
can bend the tail, or you can flip it over. If you have lots of room, you can make
the tail flat out. You can make the body longer. There is room to move.

"But on this log, the most important part of the drawing Norman will do is
the head measurements on the major figures. And there are a lot of head measure-
ments that have to be bang on. They can't go any shorter, otherwise they'll start
looking wide. So the proportion of the head has to stay. Once that is put down,
he can move it maybe a thumb's width. Maybe. Or if you overlap something—
like the Whale biting the Bear—you can suggest the head under the overlap-
ping, but each head has to have that certain length. Norman always starts his

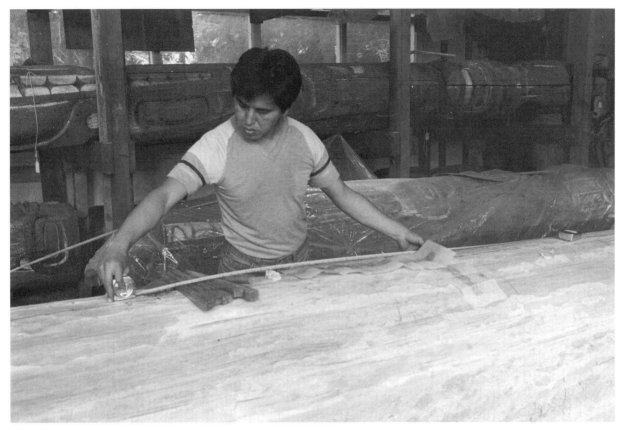

drawing with the head. He maps out the width and then puts the length on. The head has to be longer than the width so it isn't like a block head. Everything else can go up or down. The legs can be extended; the arms can be pulled in or lengthened. But the head, that's the important thing.''

Going into greater detail, Norman adds, ''When figuring out a head, you take the width as the width of the log. The length of the head is generally the width of the log and a bit, say a quarter more. It's something you get a feeling for, you know, like in cooking where you put in a pinch of salt. A Nisga'a-style face is divided into three equal spaces: the forehead, the nose, then the chin and upper lip. There's not much of a jawbone on any of them.''

Then he explains that today carvers occasionally make a miniature pole as an intermediary step between the drawings and a larger pole. Such a small pole provides the opportunity to work out the spacing of figures, as well as generating a salable piece of art. However, because of the tight deadline for this pole, there is not the luxury of doing anything extra.

While Norman draws in detail, Chip continues on down the pole, marking the length of each creature.

The crew's learning is not confined to the carving shed. Norman takes them to the museum, explaining, ''I call these poles my silent teachers.''

During one of the first days at the carving shed, Norman calls a break and takes the crew over to the neighbouring Museum of Anthropology. He explains, ''Anything I do, I have to reach back to the old people or to an old pole before I can go ahead. This is what I do on every project.'' For advice on this pole, Norman keeps in touch with Rufus Watts, his *ye'e,* or grandfather.

For most of the crew, it is their first exposure to the old poles in the museum. Norman discusses contrasting carving styles, pointing out that the figures on Tsimshian-style poles are cut deeper than on Haida poles, producing a more rounded, sculptural feel. Their attention then focusses on the Eagle-Halibut pole attributed to Oyai, which Norman and conservator Roy Waterman repaired for the museum in 1976. Finally, he moves to a Gitksan memorial pole, the top of which is actually wider than its base and which is crowned with several figures. He encourages his crew to check out the pole's unusual proportions. Out come tape measures and sketchpads as the carvers move in closer to see and feel for themselves.

Chip notes, ''Visiting the museum gives me and most of the younger guys some insight into what's expected. It's a boost and it's also very spiritual. We're standing there looking at an old pole and saying, 'That's incredible. How did the carver do that?' And then you realize that one day people are going to be looking at our pole and saying, 'I wonder how they managed to get something like that done?' I find a museum draws out a lot of feelings in me. You look at some of the stuff in there and you wonder, 'Who were these people? Where do they come from? Where are they?' It makes me think about what I really want to do.''

Whatever benefits the visit has for the rest of the crew, for Norman it is a productive part of wrestling with the problem of redesigning the pole. ''My design was for only one third of the wood to be cut off the back of the log, but we ended up with only half a log for this pole. When that happened, the challenge was to drop everything and start all over with the same story. I kept the same drawings—they were complete in my head—but the sculpture, the actual style, changed. I had to redo it from beginning to end, to put it flat, using the drawings as guideposts. I used part of that Gitksan pole's style, part of Oyai's style and came in between.

''Different poles act as teachers; different circumstances force you into new ideas, new styles. I call these poles my silent teachers; the only thing that's missing is the correction as you go along carving.''

Back in the carving shed, the next step is to translate the rough sketches Norman has drawn onto the log into more precise outlines of a Human, a Bear, a Whale, a Moon face and a Raven. ''When you draw on a log, you have to see in three

Aware of the significance of these initial cuts, the crew watches as Norman uses first chainsaw, then axe, to begin slanting the Raven's forehead.

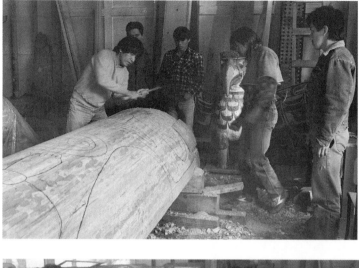

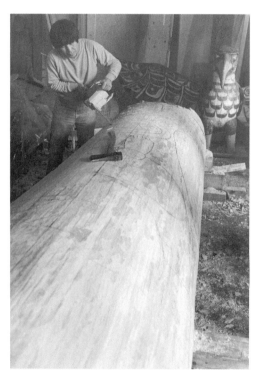

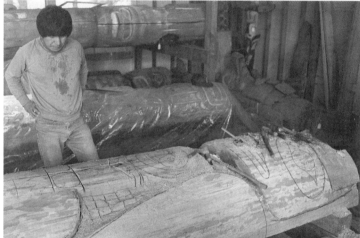

Before the rest of the sketches are even completed, Norman makes the first cuts on the topmost Raven figure.

His shirt soaked with sweat, Norman mentally maps out the next cuts on the Moon figure.

dimensions right away,'' Chip says, trying to explain to the apprentices the difficulty of visualizing. ''You can see the lines and know how it comes together, but that's not the way the nose looks. You have to see it down, wide, deep.''

The upper section of the pole is already well sketched, so Chip and the crew concentrate on drawings for the lower two thirds of the log.

Norman fires up his smaller chainsaw, the noise sudden and loud in the carving shed. He begins his first cut at the top of the pole, sloping the Raven's forehead. Norman works with intense concentration, mindful of the repaired corner, outlining a series of shallow cuts in the wood. Switching to an axe, he quickly knocks out the excess wood. The rest of the crew gathers to watch. Again Chip encourages them, ''Imitate Norman's stance, his style. See how he uses the chainsaw. Really watch and do what he does.'' There is a strong sense of practised skill about the way Norman uses chainsaw, axe and adze.

This roughing-out technique with the chainsaw could be done with a chisel and adze, as well. The chainsaw is simply faster. Chip summarizes, ''He's sloped the forehead back and then cut the bottom of the chin and the top of the Moon face. In other words, he's just cut all the wood that's going to come out anyway, and he's popped out the face and wings so you can start seeing, roughly, what has to stay and what has to come down. He's showing us the background compared to the wing, for example. When you make those cuts, you have to see your finished product as you stand there, even though it's just a log.''

The roar of the chainsaw does not disturb Norman's intensity. As he cuts his way down the pole, the blade of his chainsaw outlines each main figure with ease. Each time he gets to an area of wood that he wants to eliminate, Norman cuts a series of parallel lines through the excess. Using either axe or adze, he strikes blows against those lines, popping out large chunks of wood. Norman calls this slicing technique ''cake cutting'' or ''making a bread cut.'' It is an efficient means of getting rid of a lot of wood but requires skill and a strong sense of how deeply to cut.

Confidently, Norman moves in to work on the legs of the Moon figure. He cuts deeply, feeling for the bend of the ankle, then follows with a shallower cut to outline the top of the knee. Using his adze, he rough-cuts the slant of one leg. Satisfied, he calls Chip and directs him to match the second leg to the first. When Norman finally steps back to take a break and survey these first cuts, he is soaked in sweat.

For two weeks, the crew has worked on the log to get it ready, to get it round. Then, in the space of one day, the design goes on and the first cuts are made. It seems as if the pole has suddenly opened up. Norman calls it an explosion.

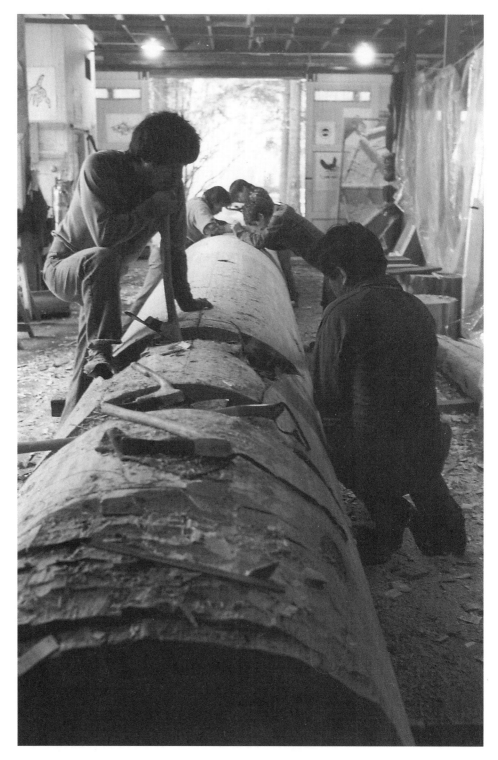

The crew continues
transferring drawings at
the base of the pole as
Norman and Chip cut
out figures with chainsaw,
axe and adze.

ROUGH-CUTTING *the* FIGURES

18 to 24 April

When the first cuts were made, the pole entered the second stage, which is called "roughing the pole." For the benefit of his apprentices, Norman has drawn the remaining figures in greater detail on tracing paper. Often only one side of a figure is drawn; crew members transfer the first side of the figure onto the pole, then flip the paper to do the other side.

While each tracing may look like an exact, finished drawing, Chip explains that it serves only as an approximation. "It's a way to make sure the figures don't clash. Once both sides are drawn on, you can step back and see in your mind's eye whether the figure is too crowded, too small or too big, or that it works. Most of the time we adjust as we go along." He points to the outline of the Human's face. "Look at the point of the bridge of the nose on this tracing. That's not how thin it's going to be; that's just an exaggeration. In actual fact, you would move that over a bit so it would be wider at the bridge of the nose. You have to be able to see that the eye sockets are maybe too big, or the mouth is not Norman Tait's style of mouth. The tracing is just a face or a figure that fills in the proportions, so we can see.

"In the olden days, you didn't trace. You'd just measure using your hand and then draw. The tracing is just a guideline for these guys. It helps us get in there and get out of there quickly. It's on and we can start cutting."

For Chip, the designing and drawing process is more difficult to master than learning to carve. He concludes with conviction, "It's easy to trace, but to learn to draw, to learn to *draw*—that's the thing."

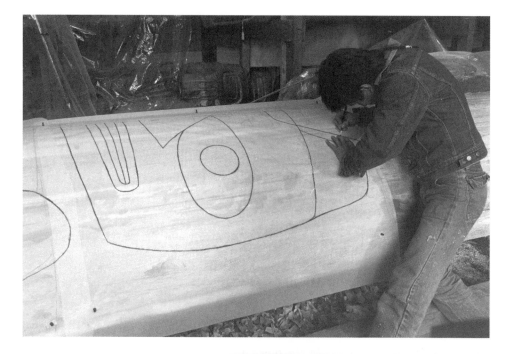

Each drawing provides an
approximation of the
figure's proportions.
When transferred onto
the wood, it can be
adjusted for size and
relation to other figures.

Hammy is honoured
when Norman asks him
to cut on the pole. Here
he concentrates on
defining the Bear's chin.

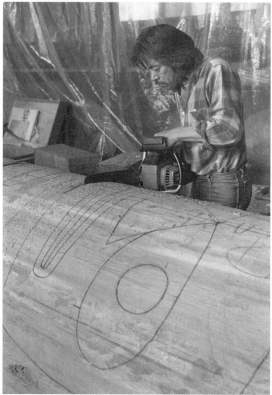

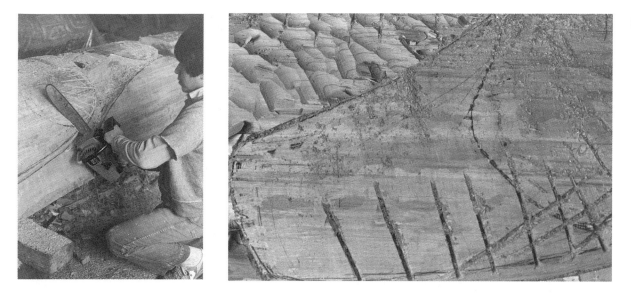

Norman expects his crew to learn *what* they are carving, as well as *why* each figure is part of the pole. "In the beginning I told them what each figure was going to be and what each had to do with the other. Then later I just told them the story of the pole. I banged it into them and told them to find a way to remember it; you know, 'If you have to, get together and exchange parts that you each remember—but learn the story!' I warned them, 'One day when you least expect it, I'm going to tell one of you to tell the story to a visitor.'"

Tape measures and marking pencils handy, the carvers work the length of the pole, transferring faces, arms and legs from the tracing paper onto the wood. When the tracings of most of the figures are complete, Norman asks Hammy to cut the outline of the Bear's head with the chainsaw. The request makes him the first of the crew after Chip to cut on the pole. It is a moment that Hammy remembers with pride. "My eyes just popped right out!" He adds, "Norman called me 'professor,' and that felt great because professors are supposed to know everything."

More and more figures are cut. Norman and Chip concentrate on explaining various cutting and carving techniques to the crew. Working on the Whale, Norman demonstrates both deep and shallow cake cuts. Outlining a side fin with the chainsaw, he slices deeper to cut out the background wood. Then, on the base of the tail, he angles the saw blade severely to begin sculpting the roundness of the curled flukes. Chip describes the result of this kind of cutting technique as "popping out the wood." "You're taking down everything that you don't need in order to pop out what you do need. It's hard to understand at first, but it really works—by taking something away, you get something more."

Left:

Norman begins a series of angled cuts on the upturned Whale's tail. Both chainsaw and adze are used to remove large quantities of wood.

Right:

A close-up shot of one of the Whale's tail flukes shows sketch lines, chainsaw cuts and adze marks.

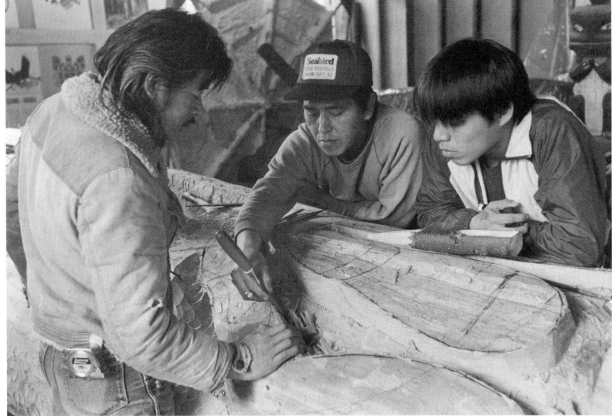

Using his chisel blade, Chip measures the depth of the cuts on the Human.

The carvers range the length of the pole, sometimes standing on it to cut a figure with the chainsaw, sometimes squatting over figures as they adze. With each passing day, they grow increasingly confident with their tools.

Norman pushes them to make deeper cuts into the wood. ''Why be afraid of it? It has to be cut. I'll show you how deep it has to go and how it has to be done.'' He states that this is the first time he has ever started off cutting so deeply on a pole.

Chip is keenly aware that the cuts are going deeper. ''We've changed our style a lot over the last ten years. We used to think three to four fingers deep was really deep. Now Norman comes along and puts his whole hand sideways in there and says, 'I want it to go that deep right *now.*' Then, after a while, he'll turn his hand on end and say, 'Eventually I want it *that* deep.' That's a big change in his style.''

Hammy explains at one point, ''When we started this pole, there were cuts, cuts. It came out so fast because there were three of us cutting at the same time— Norman, Chip and me.'' He continues, ''There's a lot of pressure, a lot of

pressure. I'd never done much carving before, but I started remembering what I'd done with Chip, and it started coming to me. And after a while, that pressure was gone.''

For the next few weeks, the carving shed is alive with the constant thump of energetic rock music and the steady cadence of adzes mixing with the rhythm of mallet hitting chisel. There are brief silences when Chip or Norman explains a technique or discusses the sketches of the pole that have been tacked up on a board. Regularly, all else is drowned out by the rev and whine of the chainsaw.

Chip is more confident as foreman, but he still finds long stretches without Norman uncomfortable. ''A couple of times I wished I could get hold of Norman. I would look at one of the other carvers and say, 'I'm at a loss, right now. What do *you* think?' But nothing came out. So I just had to make that decision by myself. I felt much better when I had Norman here all the time, although it still felt great when he would tell me, 'Go ahead. You're doing it, so do it!' ''

After one lengthy spell of cutting, Chip muses that people always wonder why a native carver uses a chainsaw. ''I tell them if I didn't have it, I wouldn't use it. My father used one when he had the chance. My grandfather never used a chainsaw because he didn't have one. That's not tradition; that's just availability. Tradition is how you go about finding out what you're going to do on a pole. Tradition is having guidelines to go by. Using a chainsaw is not a guideline—it's a luxury. In my village, nobody gives me a ride to work, so I have to walk every morning; here I can take the bus—it's a luxury. The way I see it, a chainsaw is just a technical shortcut. You use it to help out with rough, heavy, backbreaking work.''

Taking his line of thinking one step further, Chip adds, ''The chainsaw seems to have almost eliminated the need for an axe. I can handle an axe pretty well, but then I grew up in a village where I had to chop wood. These younger guys are still struggling, still learning how to swing the axe properly. I think they've broken enough handles to realize they don't know how to use one yet. You don't have to give it all your power, you know. You let the axehead do the work for you.''

Whatever techniques they learn or shortcuts they use, by the end of the ten- and twelve-hour days, all the carvers are tired. There is a lot of talk about keeping up the pace, but the work inevitably slows down by late afternoon. Norman describes the crew as ''showing the heaviness of the day.''

Isaac remarks, ''I told my dad that I would do anything that he would ask me and not complain. But for me, the hardest thing is the hours. We're sleeping on the bus coming to work; we're sleeping on the bus going home. Otherwise, the carving and seeing what he's looking for, I can pick that up.''

Hammy carries the additional responsibility of looking after his young son, Mark. Usually he is able to arrange daycare, but when that does not work out,

he has to bring Mark out for a long day at the carving shed. "The toughest thing about working on this pole is the hours. It's hard. It's really hard, especially because I'm close to my son. And to be away from him hurts me. Trying to take him to work is hard on him; he tells me that. We just have to work it out."

Humour serves as the best remedy for tired muscles and flagging spirits. The two apprentices have become adept at mimicking Chip and Norman, as they note with mock seriousness, "You should have had that done by now!"

Late one day, Wayne takes a break, searching out the Band-aids for a cut. "Another one?" one of the crew teases.

"This is only the second Band-aid!" Wayne defends. "It's the same cut."

Jumping in, Isaac razzes Wayne about his hard-luck hands and new haircut. "Wayne has blisters on top of his blisters, and his hair is standing up now he's working so hard."

"Nice talk!" Wayne retorts. But he's wearing a smile now, even if it is a tired one.

25 April

At the end of these full days of carving, the apprentices are still at work making their tools. Experienced carvers would, of course, come to a new job equipped with their own set of tools. For a totem pole, they need an axe for taking off the bark and for chopping out large sections of wood, heavy elbow adzes for rough shaping, and perhaps a chainsaw. Isaac explains that each carver should have two types of adzes: a big two-handed adze, which the crew members nickname the "murder adze," and a lighter one-handed adze for finer work. "It's nice to have a medium-sized one and a smaller one for finishing, but not all of us got that far," he admits.

As the roughing stage progresses, a set of inch-wide to inch-and-a-half-wide chisels of good quality steel is also necessary, along with a handmade wooden mallet to drive them. Made out of dried alder wood, this mallet takes the place of the traditional hand-held stone hammer.

For the finishing stage, Norman likes his carvers to have three knives—one with a straight edge, one with the blade strongly curving up at the tip, and a third with a gradual bend that he calls a "slow-curve." Ideally, carvers have two sets of these knives. One set has longer handles for heavier, two-handed work; the others, used for finishing work, fit comfortably in one hand.

Until now, Hammy has had only a timber adze to work with, so he joins Wayne and Isaac in making proper elbow adzes. The metal for the blades comes from a variety of sources, depending on each carver's budget, experience and preference. The crew members are experimenting with old automobile leaf springs. Isaac comments, "We made our blades out of the old steel someone had brought in from a water wheel and from junked car springs. It was really good. The older

steel seemed much better, so we'd look for really rusty ones.'' The cutting edges of the adze blades are gently rounded rather than straight across.

For springy hardwood adze handles, the carvers head out into the bush, looking for alder (also yew, cherry or broad-leafed maple) trees with limbs growing out of the trunk at the desired angle. Once these elbow-shaped junctures are cut out of the tree, the carvers then carefully cut away the wider trunk portion to create a flat surface that will hold the adze blade. Handles for heavy-duty adzes come from thicker branches and are longer. Although other carvers use epoxy or bolts, Norman's carvers are taught to bind the blade onto the wooden shaft with several feet of twine, wrapping it tightly round and round the head and blade.

For knives, some carvers send away for high-quality tool steel; others try stainless steel. Chip has found that converting metal-cutting files produces good results, so he gets the crew scouting for files to use. Isaac says, ''We'd try to find old file blades for fifty cents or a buck at flea markets or secondhand stores, but you could also buy them new. Knife handles are carved out of wood, personalized by a crest animal carved on the haft if there is time.''

As for chisels, once the crew started getting regular paycheques, most opted to purchase a good set. ''It was just a lot easier,'' Isaac admits.

The hours are long. There are few days off. The pressure grows. Chip is well aware that Norman feels the crew should have finished making their big adzes by now. ''The guys were working on making their tools after hours. They had no choice. We were tired, and I still had to teach them. Chip recalls one night when he was staying with Andy Morrison, working on adzes in the basement. ''His wife yelled down, 'Geez, you guys, it's three o'clock in the morning. Aren't you going to bed?'''

One Saturday, the pressure of the job gets to Chip, and he blows up at his crew. The carvers work in silence for a long time after that; fortunately, tomorrow is Sunday and a much-needed day off.

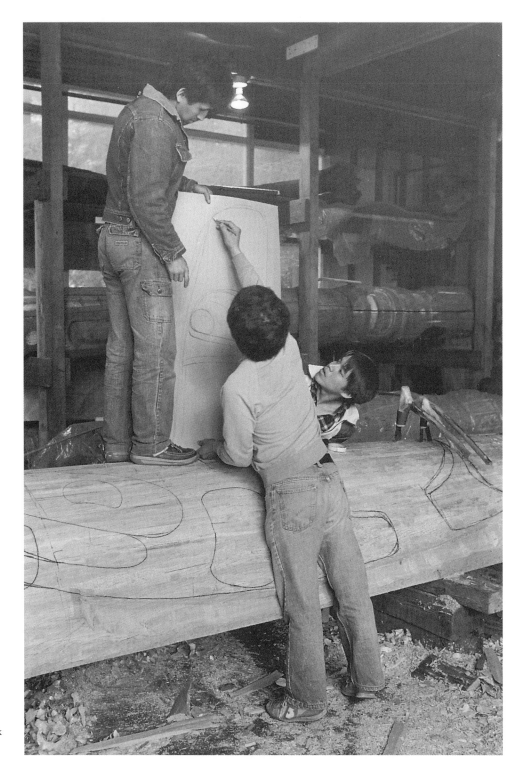

Norman sketches the fin shape he wants for the Whale onto a piece of cardboard. Wayne will then cut it out of a chunk of cedar.

CARVING *the* ADD-ON PIECES:

BEAK *and* FIN

Many Northwest Coast totemic figures are recognizable by specific characteristics. The Raven is known by its large straight beak, for example; the Killerwhale can be recognized by its dorsal fin, blowhole, large head and numerous teeth; the Thunderbird by its mighty wings, hooked beak and tufted ''ears.'' Some of these figures refuse to sit neatly with others on a totem pole. According to each carver's vision, their mighty beaks or wings or fins keep sticking out from the pole. Such add-on pieces must be carved from separate pieces of red cedar and then attached to the pole. When skilfully carved, these add-on pieces are part of the flow of the entire figure.

There are technical considerations that must be met if add-on pieces are to last as long as the rest of the pole. Primary among these is how well they fit onto or into the pole and how strongly they are attached or supported. The forces of wind and rain, lack of adequate adhesive, and even an insufficient number of nails, bolts or dowels are common reasons why add-ons may not survive. The result is that in museums and graveyards, many an old totemic Eagle is lacking its beak or a Thunderbird missing an ear. Other poles surrender their carefully carved wings to the forces of wind and rain, leaving the bare timbers that supported them sticking out from the pole.

Usually, add-on pieces are carved at the same time as the pole, not after. ''You do that so it's proportional,'' Chip explains. ''Then you can see right away if it's too small, too big, too wide, too thin, too ugly! You keep it all together so that it will fit in. And sometimes it doesn't. That's happened. I've worked on something, then found out that Norman didn't like it. 'No,' he said. 'No, it's

not what I want. It's too small. Let's start over.'''

There are also considerations about how the add-on pieces of wood will dry compared to the rest of the pole and how to attach them. Chip dismisses these as secondary technical matters. ''You have to make sure the wood matches and everything, but that's the minor part.'' Gesturing towards the pole, he explains, ''When I put something on there, I want to make sure it *fits* the figure, not just that it was the piece of wood that was conveniently available. It's got to look like a fin, the kind of fin we want.''

While the add-on pieces progress with the pole itself, they are not generally attached until the pole is near completion. ''We don't want to damage them,'' Chip notes. ''And if we put them on, then we really have to baby the pole—and the pole already needs kid gloves. When you put them on at the end, it's like a baptism, like saying, 'There you are, you're finished now.'''

19 April

Early on in the rough-cutting, Norman calls his two young apprentices aside individually and assigns them each an add-on piece. ''I wanted them to each have a special job they could be proud of,'' he explains. Wayne is to be responsible for the Whale's dorsal fin; Isaac will handle the Raven's beak. Their efforts on these pieces are expected to fit in with their other work on the pole.

Pride is not the only consideration Norman has in making these assignments. He states, ''It was a risk letting Wayne do the dorsal fin, but I felt I was losing him. He was coming to work late, not giving it his all. I thought getting him back on track was the most important thing, so I quietly approached him and asked if he would carve the fin. He thought about it, and then said he was honoured that I asked him. I said, 'Well, honour the pole and do it right.' That kept him on the job.'' Norman shakes his head, adding, ''A lot of heading up a carving project is psychology!''

Later on, Wayne admits, ''Boy, I was sure lucky to get assigned that fin.'' He laughs as he recalls his thoughts. ''What I really wondered was, 'Are you sure you want *me* to do that?''' He continues, ''Getting assigned the fin was quite a boost. It gave me a piece to be responsible for, and I thought that was great. Actually, it has all been great. But I realize they're just showing me one step at a time. I finish one thing, and I can't just go on to the next thing. I have to ask somebody to show me the next step, because I've never done it before. This is my first pole.''

Wayne locates a large piece of cardboard and climbs up onto the pole. He holds it in place over the Whale, while Norman sketches the size and shape of the fin he wants.

Norman also gets his son started drawing a template of the beak on a piece

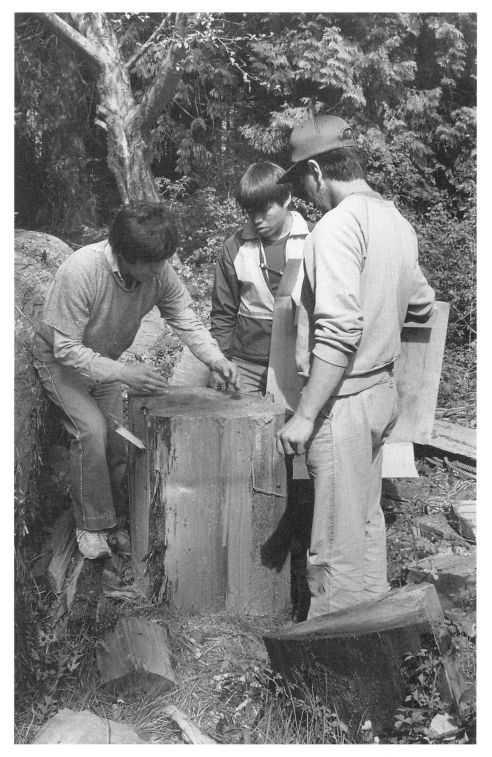

Isaac listens as his father and uncle explain how to position and saw an add-on piece out of a block of wood.

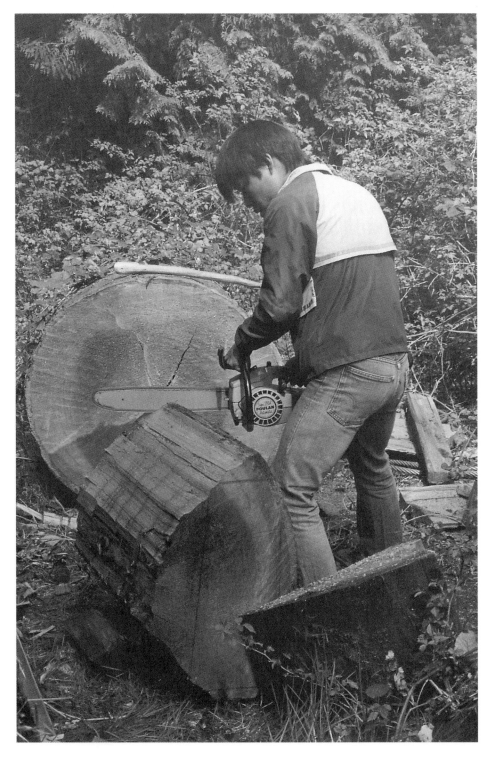

Working cautiously, Isaac begins cutting the add-on Raven's beak. He works oversize, giving himself plenty of margin for error.

of cardboard and then finding a piece of wood to fit. Isaac explains, ''First we looked at the drawings of the pole, the proportions. We didn't measure it to get the right size; we went by eye. We held up a cardboard where the beak would go and drew the beak on the cardboard. We started oversize, of course—we always do—but quickly notched it down.''

Chip then details how to select the right piece of wood and get the add-on piece out of it so that the wood does not split up or crack. Isaac and Wayne are forced to become more familiar with the chainsaw as they each cut themselves a sufficiently large chunk out of some extra wood. Then they sketch the shapes of the beak and fin onto the pieces of wood, allowing a generous margin for error when cutting. Norman and Chip oversee the young carvers as they gingerly use the chainsaw to rough out the shapes. This first-time procedure of cutting and shaping an add-on piece goes very slowly, but Isaac and Wayne are mightily proud and relieved when they each finish up with a roughly shaped, oversized block of wood, ready for refining.

Describing that first chunky block of fin, Wayne declares, ''It was huge. It took two or three people to haul it at first. You'd think I'd remember the exact moment when I stopped needing somebody else to help carry that fin, but I don't. I just realized one day I was carrying it around by myself.''

Once the pieces are cut out of the blocks of wood, the centre lines are drawn on. The apprentices are assisted in this task the first time, then left to work on their own. The skills these two apprentices are acquiring are even more important than the piece they will produce. As Chip states, ''What these guys learn on doing the beak and fin are the techniques they can use for everything—the intensity, the mapping, the cutting, the adzing. They learn to trust themselves and rely on their own instincts.''

The amount of time the apprentices work without supervision is considerable and reflects a deliberate teaching style. ''On this totem pole I used my father's example of teaching,'' Chip explains, recalling how he fought against it as a teenager. ''I knew I had to learn the first time he taught me or get heck if he had to tell me again and again and again.'' Mellowing that principle slightly, Chip tells the crew, ''I showed you once. And I'll show you again, but I won't do it another time. You'll have to sit down and figure it out. That's the way I was taught.''

The chunky fin and beak need to have a lot of wood cut away, so the apprentices try the cake-cutting technique that has already been demonstrated several times. Firing up the chainsaw, they cut a series of parallel lines, then knock out the wood in between with a heavy adze. When Wayne tries the technique, he does fine the first time. But on the second attempt, he slices too deeply with the chainsaw. ''I almost lost it,'' he confides quietly. ''I almost lost that whole thing

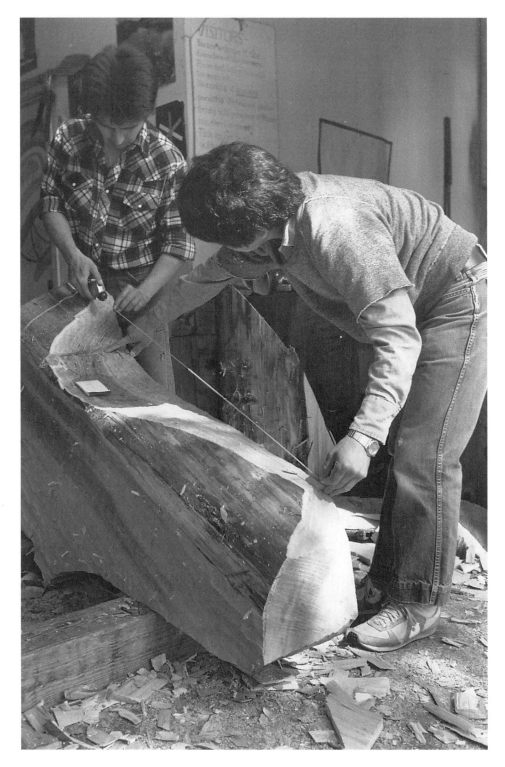

Now that the add-on
Whale's fin is roughed
out, Norman helps
Wayne to establish its
centre line.

As the warm spring weather beckons, Wayne moves his fin to the double-door entrance of the carving shed.

when I used the chainsaw to take out the side. The fin is supposed to be straight up and down, but now it's dented in. I don't know if it's just me, but I've always been scared of that chainsaw." He pauses a while then adds, "I had to take a long walk after that."

The mistake leaves more of a mark on Wayne than it does on the wood. "It was probably the worst time for me on that whole pole," Wayne admits. With relief in his voice, he says, "Norman wasn't worried about the fin; he was worried about how I reacted to it. He just said, 'Don't let it screw you up.' You know, don't let it get the best of you."

After a quick appraisal, Chip tells Wayne there is still plenty of wood there; all they have to do is move the centre line over. Wayne explains, "That's why we've been told throughout to try to leave room for mistakes when you're working with wood. I think I worried more about it than they did because they knew exactly what was going on. I was just going step by step."

The apprentices spend part of each day working on their assigned pieces, hauling the beak and fin outside into the warm spring sunshine. The rest of the day they give their energy and attention to the figures on the pole.

One afternoon Isaac lifts the beak onto the pole and carefully sights down the pole to make sure that it is sitting straight. He and Norman talk over the next steps in the carving process.

Soon the fin is also ready to be hoisted onto the pole for the first time. Every-

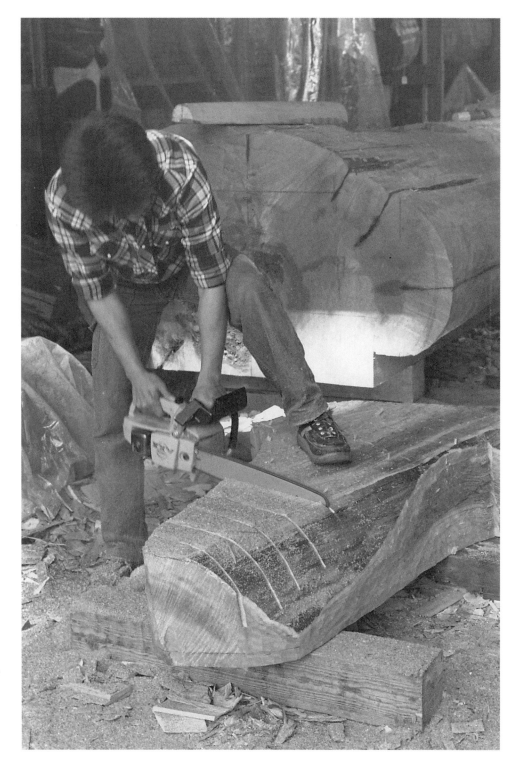

Unaccustomed to the chainsaw, Wayne gingerly begins a series of cake-cuts that will quickly remove wood and thin down the fin.

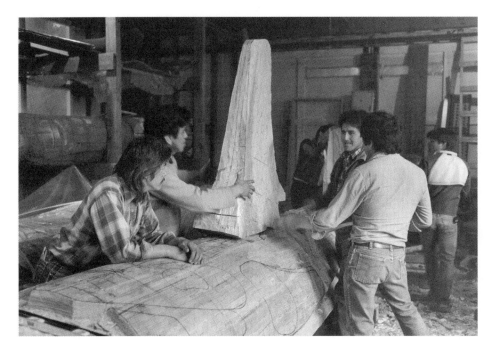

Although far from its
final streamlined shape,
the chunky fin still excites
the crew when it is first
lifted onto the pole.

one is excited. Wayne smiles in pride. Isaac says, "We were all asking, 'Is it straight? How does it look to you? Is it straight?'"

Chip adds, "These guys really felt good seeing the fin on the log for the first time. I enjoyed it myself." Chip is especially delighted that the crew seems to be coming together. "Their confidence is high, and they are starting to *see*." For himself, Chip realizes he is making fewer phone calls to Norman for advice.

With the add-on pieces taking shape, the next step is for Norman to teach how to cut the slot-and-tab arrangement (technically called a mortise and tenon joint) that will eventually anchor each piece to the pole. "It's really just a tongue—a tab, eh? But it's got to fit really tight," he explains to the circle of serious faces.

With impish humour, Norman adds, "When the dowels go in, you put in glue . . . and pitch . . . and cement, and then you tie it down!" The crew breaks into laughter.

Isaac and Wayne each begin carving a level platform on the pole where the bases of the beak and fin will sit. Next they locate the centre line on each piece and get help calculating the measurements of the slots to cut in the pole. Isaac begins chiselling away the wood in his slot, working from the centre out. Wayne works at cutting down the tab, or peg, at the base of his fin. Chip climbs up onto the pole and demonstrates a delicate cut with the chainsaw, using it to start the slot and get into the wood.

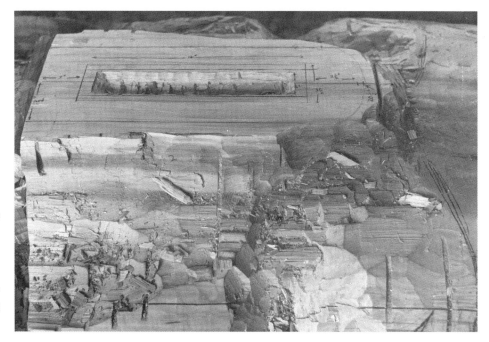

A slot and tab (or mortice and tenon) technique is used to join add-on pieces to the pole. Here, measurements for the slot are drawn on the pole and the first wood taken out.

22 April

Isaac now has his tab and slot roughed out to the point that he can try fitting the beak into the pole for the first time. He is all smiles, eyeing the piece from every angle to check that it is sitting level. Chip notes, ''You could see it was rough—even the landing that the beak was sitting on was rough—but I thought it was a good start.''

Now Isaac begins the seemingly endless process of fitting and refitting to get the base of the beak flat and flush with the surface of the pole. Chip explains to him that he can either mark and trim wherever he sees the two surfaces rubbing, or he can use his grease marker to blacken the flat platform on the pole before a fitting. ''Then when the beak goes in, the black will rub off on the base of the beak, and you can actually see where it is touching.''

Chip is sometimes caught between Norman's expectations and the crew's output. Usually he can handle the pressure, but on occasion he blows up at the crew. ''I was so intense, I had a hard time relaxing. I found that Norman had to draw the humour out, because I couldn't,'' Chip admits. ''Lots of times, lots of times I was afraid I might lose somebody on the crew. At times you could just walk into the carving shed and feel the tension. Sometimes I just talked tough for show and did what I call 'kicking the dirt.' Other times I was just rotten and really gave them heck. But I had to. Otherwise I would have been working with three individuals, and that's not what Norman wanted. He wanted me to get a crew

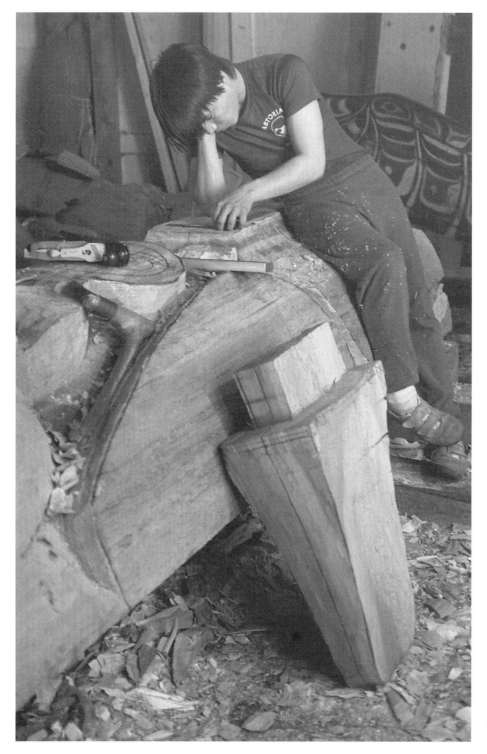

Isaac studies the flat pole surface, trying to figure how to get it flush with the base of the beak.

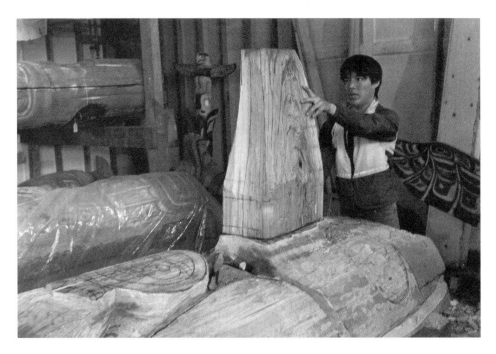

Each add-on piece must fit snugly into the pole, sit flat so that it doesn't rock, and square up with the rest of the figures.

together. And I can't get a crew if one guy won't listen.''

Hammy says, ''Chip or Norman don't holler a lot, but they do get mad. Like the other morning when I came in late, I could just feel the vibrations, and I knew. I don't blame them for that. Sometimes when Chip gets mad at us, I figure he's getting a lot of pressure, too.''

The carving shed is filled with the four-beat rhythm of mallets hitting chisels. ''Tap, tap, tap, tap.'' (Pause.) ''Tap, tap, tap, tap.'' Norman gives Hammy the assignment of cutting out the ceremonial doorway. ''I knew he could handle it, and I wanted him to fit in better with the crew. He still felt like a new boy, so he needed an important job.''

The responsibility for maintaining a healthy emotional temperature among the crew is one that Norman takes seriously. ''Sometimes I go to bed chewing on a problem—maybe somebody isn't pulling their load or has problems at home and isn't concentrating. I fall asleep thinking, 'I've got to pull this guy up shoulder to shoulder with the rest. How am I going to do that?' Usually in the morning, driving to work, the answer is there.'' Most commonly, Norman talks privately with the person. ''I start by just trading comments while he's carving on the pole. Then I might say, 'Let's go outside where we can hear each other.' Then I first ask him how *he* feels things are going. Later, I might add, 'Well, I noticed you haven't been giving it your best effort. I know what you can do when you're

really going a hundred per cent.' So first you hear what he's got to say, then you build him up and send him back to work feeling good."

He cautions himself, "I have to be careful not to compare these guys with other professional carvers, like Joe David. I've got to watch my expectations, to keep myself at their level and think what they are thinking."

24 April

Wayne finishes cutting the slot in the pole and shaping the fin's tab; then he starts the fitting process. "We kept putting it on the pole, taking it off, putting it on to fit that peg and trying to level it. When you're putting that fin on a round log, you've got to have a flat surface to keep it from rocking. And you have to have a good fit. That's what took a lot of time."

From time to time, other native carvers or family members drop by the carving shed to take care of business or just see how the pole is coming along. One of the most regular visitors is Ron Telek, Hope's son; Norman and Chip are his uncles, Wayne and Isaac his cousins. Norman's daughter, Valerie, is also around. Both head carver and foreman take note of this interest and file it away for future jobs.

Right now, Ron is helping Wayne lift, fit and adjust the fin. Wayne explains, "We used a plumb bob with that peg to balance the fin. Every time we put it back on the ground, we'd adjust it level. We'd use wedges to keep it straight, and finally we'd measure from the bottom of the fin, not the peg, to the ground on both sides until it was level. And then we'd get the centre line on. We kept it on right through the whole process. Any time Chip came over to see what we were doing, the first thing he'd ask was, 'Where's your line?' I don't know how many times he must have told us that."

Norman smiles over his foreman's insistence on centre lines. "I really beat that into Chip. When he was apprenticing with me, I told him, 'When you don't put your line in, it's like driving down a highway without a centre line. That's when you get accidents, and the last thing we need on a totem pole is accidents.'"

Once the fitting has started and the fin is roughly in place, Chip reminds Wayne, "It's going to be real slim, streamlined. This is where your good adzing comes in handy, so you can make that all smooth." Wayne looks tired and frustrated at the mention of any more work. "I'm not saying that this isn't O.K., but it could be better," Chip encourages. "You start with a line and work over it so the whole thing's smooth. But I can't expect you to learn that overnight; it took me a long time."

Getting the fin to flow into the body of the whale is especially tricky because the lip of the fin cannot be thinned until the piece is ready to be attached.

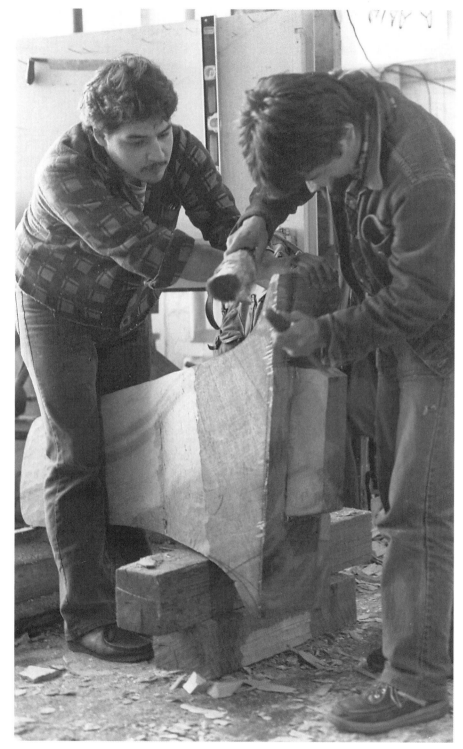

Wayne chisels the tenon, or tab, at the base of the fin while Ron Telek holds it steady.

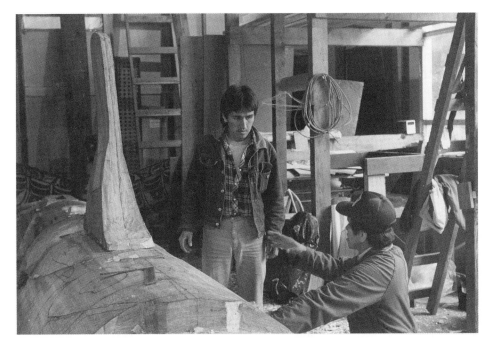

Once the fin has a good fit into the pole, Wayne's next job is to adze it into a flowing, streamlined shape.

"Norman helped me with tapering it off, with the flow," Wayne explains. "He's concerned with the flow of the whole shape, eh? He says that's the whole thing behind Indian art on the Northwest Coast. He says most critics have lazy eyes when they look at a design. The only way you can keep their attention is if you have a flowing pattern where they follow the flow line, eh? After you get their attention, you've got to keep their eyes busy. Like one line will lead to another until they go through the whole design, instead of having a line that comes to an abrupt halt.

"Well, Norman especially wanted that fin to flow right into the back of the Whale, instead of making it look like we just plugged a piece of wood in there. He said one thing about animals is they've got a lot of flow lines, beautiful flow lines."

After each session of fitting, the apprentices wrap the fin and beak in plastic. Isaac explains, "They have to dry slowly, so we cover them with plastic all the time."

Chip agrees. "They are wet, really wet, to begin with. If the wood dries too fast, the pieces will check and split because they are both thin, especially the fin."

Norman and Chip are also keeping an eye on how quickly and evenly the entire pole is drying. They look for major cracks, other than the smaller checking that normally occurs. The trough cut out of the back of the pole helps ensure that the front and back are drying at the same rate. However, if the carving sur-

face appears to be drying out too fast, it may be either covered over when not being worked so as to keep moisture in or watered down to add more moisture. A pole carved outdoors may require a tarp overhead to prevent direct sunlight from drying the carving surface too quickly.

Late in the day, Norman looks at the two apprentices and comments, ''Boy, you can see how tired these guys are now.'' He smiles, nodding at Isaac and his beak. ''This morning he could carry it by himself, but now he just asked Wayne to take the other end. The beak is one quarter of the size it was this morning, and now he can't pack it by himself.''

25 April

Within a month after starting work on the pole, Norman calls an evening meeting at his sister's house to discuss regalia. Hope is the only one of Norman's sisters living in Vancouver, and she has a great deal of experience making button blankets for family members. She addresses the carvers who are designing the blankets and the women of the family who will sew them. Isaac's mother, Jessie, will make a blanket for him; Wayne's sister, Carol, will sew one for him and for herself, as well; Barb and Mitchell Morrison will help Hammy; and Hope will make one for her son, Ron Telek.

First, Hope tells the assembled group about the basic requirements and expenses. The dark, navy-blue melton cloth for the bulk of the blanket costs about $20 per metre; each blanket will require about two metres, depending on the size and style. She puts a full blanket around one of the carvers, demonstrating how it overlaps or crosses in front. Then she shows a smaller cape-style blanket, which just meets in the front. Hope explains that the red wool will be used for each blanket's deep border and for the crest design on the back. She compares the two colours of the blanket to the hand print or stripes that Norman paints on his face for ceremonies—red represents life, and dark blue or black is death.

The painstaking work on a ceremonial blanket comes from stitching hundreds upon hundreds of white mother-of-pearl or plastic buttons around the border of the blanket and to outline the crest design. ''Most blankets average 1500 to 2000 buttons, depending on the size of the person and the complexity of the design,'' Hope estimates. ''Eagles take a lot!'' On the art market, new button blankets made with real pearl buttons fetch handsome prices, starting from $3000 and up.

Hope's final pitch to the whole group is about money. She reminds the carvers that the women cannot buy the cloth or buttons until they get some cash from them.

Norman announces that he also wants each crew member to have a tunic, explaining that the button blanket is to be worn only *after* the work is done. ''You

Wayne's sister, Carol, Isacc's mother, Jessie, and his sister, Valerie, study the buttons that Hope has set out.

could be lost in a crowd, but with a tunic on, we'd know where you are." His words later prove true when the pole is moved and raised. In their blue tunics, trimmed with red, the crew members are easily spotted in the crowd. He adds, "Whether there's a crest design on the tunic or not is up to you. I would. You want to show who you are."

The group breaks for coffee, and the women gravitate to the open boxes of buttons that Hope has put out on display. As they gather, she talks frankly. "What I really want is for the carvers to design the blankets as soon as they can. We'll gather the material, put it together, and each carver will provide the design. It will be up to you to keep after them, to ask them for the design. They should let you know if they want to cut it out of the material or to show you how. Once the design is cut, you worry about getting it on the blue material and not moving it. If that design moves, oh boy, you're in for it. Then you sew it on. Most of the work after that will be buttons; that will be the hardest.

"Before you put the buttons on, ask the carver where to put them. They'll tell you how they want it and if they want them spaced far apart or close together. You're sewing it for them, so you work along with the designer."

She advises, "If they want a change, ask me. Sometimes the artist can have too many ideas, and the design becomes too busy. What they want is good quality workmanship and artwork. Isaac says he wants his blanket to last for a century!''

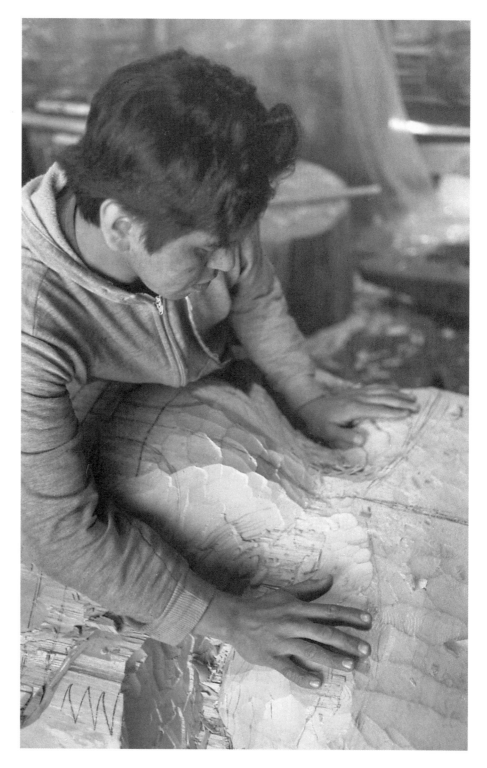

"Your hands will tell
you if one side is
higher, but you need to
practice it."

ROUNDING FIGURES *and*

CARVING FACES

A week after Norman made the first cuts, the majority of figures on the pole have been rough-cut with the chainsaw. The only exceptions are the small Wolf-cub that is cradled in the Bear's hands and the Whale's large mouth; both are still only sketched on the wood. The beak and fin are progressing well.

29 April
Norman is now ready to begin rounding, or sculpting, the blocked-out figures. He starts on the faces of three central figures—the Bear, the Raven, and the Human. Norman's heavy adze bites surely into the pole, taking out wood from under the eyes and thereby popping out the cheeks and eyeballs. Mouths are roughed out, the bridges of noses cut and foreheads sloped. Norman often begins these faces by roughing out one side of the features, while his brother matches his work on the other side.

Chip comments, "I'm still learning. I may already know how far Norman's going to go, what technique he's going to use, but the idea—he always changes the idea. So I just go right along and watch him, then match it up."

There is little talk, and a good deal of concentration. Chip pauses frequently, using his hands to measure the balance of a face. This technique of looking and feeling is one he repeatedly encourages the apprentices to use. "You have to feel it," he tells them. "What I liked about my learning was I felt it all the time. I made sure I'd run my hand over it." One more exhortation to "close your eyes and feel it" triggers a whole series of jokes up and down the pole. Chip laughs and shakes his head, "Boys!"

Some carvers even use calipers to ensure that both sides of a figure are equal, but Norman Tait prefers to rely on the older tradition of measuring by feel. "Your hands will tell you if one side is higher, but you need to practice it," he tells the crew. Norman sometimes measures using a cedar splint or chisel blade. Other times he measures by sight, a technique he calls "eyeballing it."

Chip explains to the crew, "That's why I tell you guys to take a look at the pole when you go home at night and when you come in each morning. It's all by eye. We don't want to get technical and measure everything exactly, so do it by eye."

Norman occasionally plays with having one side of a figure or pole vary from the other. "I'm not too much for this idea of one side of the pole *exactly* the same as the other. I want it lifelike, moving all the time. One side leading up to the other, not one side running with the other or a twin to the other."

Reinforcing the emphasis on realism and feeling, Norman directs Isaac to study his own hands first before carving the hands of the small Moon face figure.

30 April

Early in the week, Chip calls together the crew, along with Ron Telek, to talk about more mallet-and-chisel techniques. His objective is to define each of the rough-cut figures in sharp angular relief to the background wood. His flat chisel blade cuts a perpendicular line from figure to background, leaving a crisp right angle at the required depth. "I've done some here to show you," he begins. "You guys aren't sculpturing yet. This is just labour, so what you're going to do is to clean it as fast as you can and do a good job at the same time. That's why I want you to work with a big, wide chisel."

Chip demonstrates as he talks. "See, just take it down to the line. If the chisel's sharp, it won't hurt the wood. You've got to worry about ripping the wood, because that will show when you start rounding. It's all in learning how to handle your tools. And you can really, I mean *really,* go to town. See? That's just straight down once. And another one and another, and it's done." He tackles a second section and continues, "Read the grain; read the grain. If you go against it like that, a piece will pop off, right? So you follow the grain all the way."

"What happens if you're chiselling and screw up?" Ron wants to know.

"You don't, Ron," Chip states.

"But say you did," he persists.

Chip deliberately chisels a mistake. "See this big mark? If you've already cut your line straight up and down, and this mark is down here, right close to the pole, then you have to take it out and recut the line. But if it's up here, near the surface of the figure, it's going to disappear when you round off." He swiftly chisels out the mistake. "And don't mark the background. Don't get carried

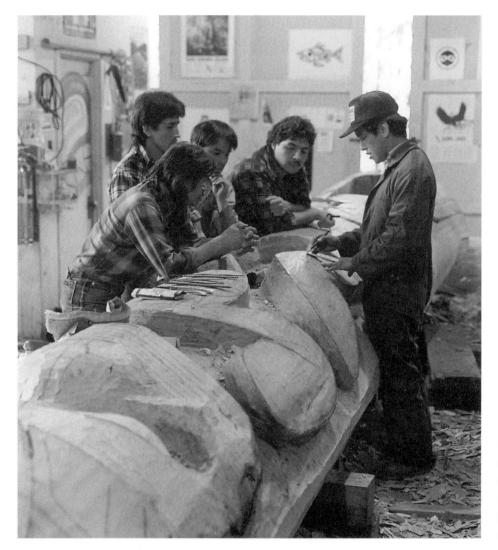

Chip gathers the carvers and nephew Ron Telek to demonstrate a mallet and chisel technique that will help define the figures from background wood.

away and go pounding like that, because when we clean that off, there's a big chisel mark that won't come out. But right now we're just worrying about making each line crisp and taking it to depth.''

Chip shows them an assortment of straight and round chisels, ranging in width from an inch to an inch and a half, then demonstrates how to cut using both sides of the chisel blade. ''This is the exciting part, where the figures start to come out. It's getting crisper. You can see it. As soon as all this is done, then the figures will be ready to round. That's when we'll need our little adzes. And that's when we're going to have fun!''

True to his word, Chip is soon ready to begin rounding the Bear's legs and

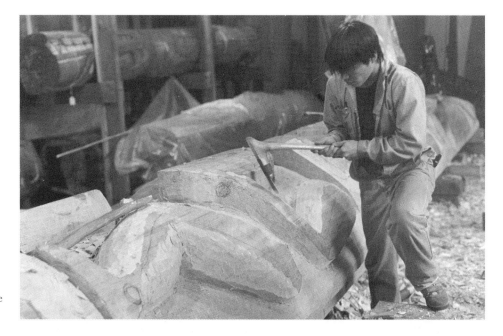

With sure strokes of his adze, Isaac begins rounding the Bear's legs and arms. The circled areas on the wood denote wrist and ankle bones.

and arms. He runs through the process to show Isaac, marks where the ankle and wrist bones will be, then turns him loose to try the work. The change is almost immediate; rounding makes the figure more sculpted, less blocklike.

The shed is filled with activity. Carvers swarm over the pole, some standing on it as they work. Others sit on the figures, swinging an adze or hammering mallet against chisel. Off to one side is equipment for making tools, and an assortment of adze and knife blades that crew members have forged is carefully laid out on one section of the pole.

1 May

For days, Hammy has been cutting away at the ceremonial door opening. Originally, this opening was supposed to be taken out for the carvers, as the back of the pole was. But now they feel possessive about the pole, and they do not want to risk any mistakes by outsiders, so the crew members are determined to do the rest of the work themselves, even though it means chopping through nearly three feet of solid wood. Hammy relies on his experience with chainsaws and the cake-cutting technique to clear away the wood in the doorway opening. At other times, he switches to his chisel and mallet. He is working a smaller area than the actual entry will be, giving himself a margin against any mistakes. ''Nobody was helping me,'' Hammy says, ''but I enjoyed it.''

Chip comments, ''The door was mainly manual work, cutting and chopping, cutting and chopping. Hammy was right into it. He stayed in there without

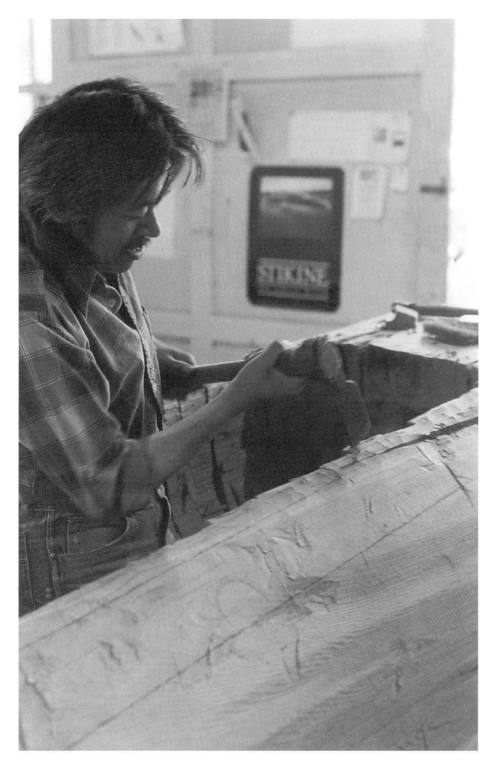

Working inside the doorway opening, Hammy alternates adze, chainsaw, chisel and mallet to remove the huge volume of wood.

the wood. That door was his great pride and joy.''

Finally, Hammy pierces through to the other side. With mounting amazement, he says to the other guys, ''I'm through! All right!'' And he hollers his delight. ''I felt great when I saw daylight,'' he states. ''That door opened the future to me. It was waiting for me on the other side, and I got through. And ever since, I've had a lot of good feelings about it.''

Next Hammy begins enlarging the opening to its actual dimensions. Careful not to cut too deeply, he continues to cake-cut with the chainsaw. The crew is under a lot of pressure to keep up the pace, but with the doorway cut through and the rounding going well, they feel good about the pole's progress.

Norman's arrival at the carving shed often signals a critique of the entire pole. Starting at the top, he asks, ''Who's working on this?'' He details those aspects of the figure that are proceeding satisfactorily, then flags a section that is lagging behind. As he moves to another figure, he wants to know, ''Who's doing this?'' ''What *are* you doing?'' or ''Why hasn't this been done?'' The carvers call this ''being in the hotseat.''

''Sometimes Norman comes down hard, but that's another lesson I learned long ago,'' Chip says. ''I used to fight back. But I found out it was easier to take the flak and learn the lesson than to say, 'Well, he doesn't know what he's talking about.' Or I used to mumble up my sleeve about something. Now I sit down and think, 'He's got a point there.' Sooner or later, everybody has to be taken down a notch. Then you get back on an even keel, and it starts all over again. Now if Norman says something, I just sit back and listen and learn. Even when I've made a decision, and he comes up and says, 'No, do it this way,' or 'Do it that way,' I listen for the explanation and wonder, 'Why didn't I think of that?' ''

These regular critiques are a chance to match the crew's performance with Norman's expectations. They also provide the foreman with a good idea of whether or not he is maintaining the schedule. Following such a session, Norman often picks up his own tools and carves the next stage on one of the figures, as an example or pattern for the crew to follow.

2 May

For one lengthy teaching demonstration, Norman tackles the Killerwhale, whose large mouth has been purposely left at the tracing stage. Chip explains, ''The trouble we had there was with the bite. Was the Whale going to bite the Bear's head, or just going to kiss up to the head?''

After spending some time thinking it over, Norman announces, ''It's going to bite the head.'' Wasting no time, he gathers everybody around and makes the cuts for the Whale's mouth. Angling the chainsaw blade in order to cut the line of teeth, he follows with deep cake-cuts. Norman hands the saw to Chip with

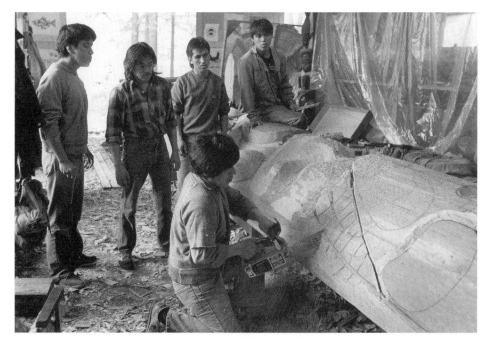

"Imitate Norman's stance, his style. See how he uses the chainsaw," Chip encourages his crew. "Really watch and do what he does."

instructions to do the same on the other side. Then he reaches for his heavy adze and cuts out the area between the Bear's ears and the Whale's mouth. Within fifteen minutes, the rough cut is complete, the wood taken out, and that part of the pole is finally taking shape. Amazed at the speed of this process, the crew members return thoughtfully to their own tasks.

Norman often talks about Nisga'a carving style and his own adaptations. Sometimes these discussions are one-on-one, as a carver works on a particular piece and Norman makes suggestions or explains why something is done a particular way. Other times he talks to the group. "On a totem pole, the features that are Nisga'a are a round forehead, round eyeballs, a large nose that's almost one third the width of the face and a grinning mouth with almost no chin. The Norman Tait style is that everything is really round—you want to put your hand on it and feel the roundness. My own personal addition is little details like wrist and ankle bones, and fat toes—I love doing that! I did that on one of my poles, and I liked it so I kept it. I've taught that to all my apprentices."

3 May

Norman is soon ready to move on to one of Chip's projects—the Bear's face. "Now that we've gone this far, the face starts to take over; you can see it. The shapes just come out, and you know if you shouldn't go any further. The hardest part is trying to find it. When I came in this morning, this face was cross-eyed

"A Nisga'a style face is divided into three equal spaces: the forehead, the nose, then the chin and upper lip," according to Norman.

and wide-faced; it wasn't really something of value."

After studying photos of the progress of the pole, Norman decides to go even deeper on the figures. "I thought this face was just about ready, but I took one look at the pictures and thought, 'God, there must be six inches to go down at least!'"

Norman asks Chip, "What's the deepest we ever went?"

Chip answers, "One hand-width—about five inches."

"Let's go another five inches," Norman states with conviction.

Chip recalls, "In some places, he didn't care how deep it went. 'Just cut it deep; it has to come out,' he said."

If Norman is now confident enough to cut deeply, Chip is still cautious. When he and Norman begin evaluating the progress on the Human's face, Chip objects, "I don't think this should go any deeper."

Norman disagrees. "I think it could go down a lot more. Look at the Bear. It's the same as the Bear. There's your chance," he encourages his brother. "Play with it!"

"O.K.," Chip says with some hesitation. "I mean, that's pretty bold for me right there."

Finishing this critique, Norman declares, "Well, it's still not deep enough."

Every carver, from apprentice to master, occasionally gets stuck on a piece and is unsure of how to proceed. Chip describes his own experience. "Most of

the time, when Norman comes in, he'll know if I'm stuck. Sometimes he'll come right out and say, 'Are you stuck?' Other times he'll say, 'Well, I think this needs to be changed.' Sometimes he will say it in a different way, so as not to put me down, like, 'I've been thinking about it a long time, and I think this needs to be changed.'"

As foreman, Chip finds it frustrating when his crew members get stuck but do not request help. "I tell Wayne all the time, 'You got a question? So ask! I'm here. If I don't have the answers, somebody else will, just ask.' But he won't. He just says 'O.K.,' and goes away. Then, about fifteen minutes later, I see him still staring at it, trying to figure out what to do."

4 May

During another critique, Norman continues his lessons on carving faces. "On this one, the eyeball started way over here this morning and moved all the way over here and back. It's found its place right there. The forehead has to come down, but the cheek has come out." He points to a different section of the face. "You can leave that. The nose is just right in proportion to the cheek and the eyeball on this side, but you have to move that side, Chip. That's what I mean about 'it takes over.' You just help it along a little."

Norman indicates a roughed-out section of face. "You've got to make this eyeball *look*. You can't just put a circle here and say that's the eye. You have to be able to picture the eyeball going all the way back inside so there's a little bulge here. Not much. It's very subtle, but it's there. The roundness continues. That's what I call carving from the inside out." He gestures to an eye on the Bear. "The bulge is way over here, so it doesn't look like it has any eyeballs at all. It's just a piece of wood. To bring all the beauty out, you have to go deeper than just the surface of the wood. You have to bring the inside out, too." The crew looks doubtful. "It's fun. That's what I'm telling you, it's fun!"

"So that's the lesson for today regarding faces," Norman concludes. "It took me a little while to learn. I did one pole, two poles, three poles—and on every one of them I quit before I got all the wood out. I wasn't sure of myself. I was afraid to go too deep, so I called them finished. Now, no matter how deep I go, I'm afraid that I haven't gone deep enough."

Isaac asks for some specific advice on the Raven's face. Norman tells him that moving the eyeball will also affect the beak's nostril. He points to the Human's face to illustrate another warning. "You have to watch your depth, too. If I go any further right now, that eyeball is going to be hanging out! Study it," he advises his son. "It will look good for a while, but it changes every time you work on it. Just keep eyeballing that eyeball."

Isaac says, "I don't find it hard working for Dad, because he knows what he's

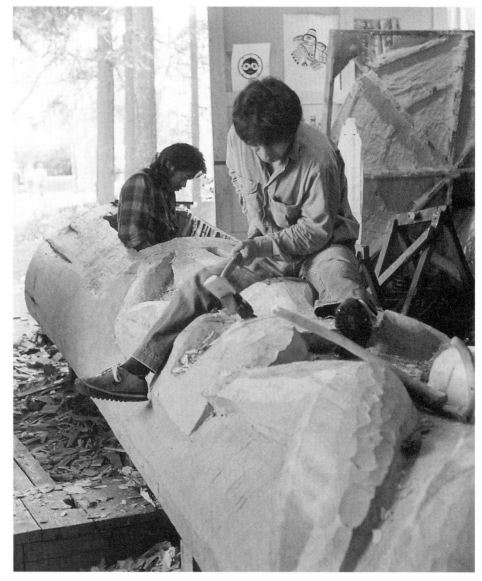

In the early stages, totem pole carving is hard manual labour. The sheer volume of wood to be cut away requires pacing and stamina.

doing. If I think about what he tells me, and I look at it from all different angles, I'll know the reason for him telling me to do something at this certain time and in this specific way.''

Norman acknowledges the difficulty of drawing and carving a face. ''Trying to get it right is still the hardest part for me. I could carve it if somebody were there to draw it for me, to say where the lines are. If I didn't have to think, I could go twelve hours a day with no sweat. But trying to get it down, going back and forth, back and forth, that's the strain.''

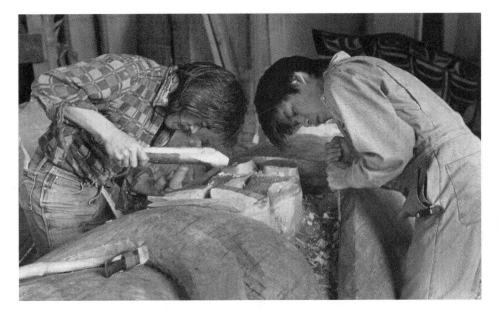

"Undercutting gives a bit more life: it puts a shadow under it," Chip explains, as Hammy and Isaac work on the Raven's wings.

6 May

Chip redraws the mouth on the Human's face, then carefully adzes the lips. Over the next week, work progresses on the other faces. The eye sockets and forehead of the Whale drop deeper in the wood, exposing its nose. Wayne cuts down the outer rim of the Moon face figure, using the mallet-and-chisel technique taught earlier. The crew members take turns working all over the pole. There is little time to savour finishing up one job before being called to another.

Hammy and Isaac work head to head, chiselling an undercut that will lift the Raven's wings out from the rest of the pole. "This is part of our style," Isaac states. The two carvers calculate that the edge of the wings should be about two inches thick, then begin gouging out the wood under the wing line.

"Undercutting just gives it a bit more life; it puts a shadow under it," Chip says. "We're treading a fine line with actual sculpturing."

Isaac moves on to begin rounding the upturned feet of the Human. Well-placed strokes of his adze soon suggest distinct toes and fleshy pads on the feet.

Norman usually maintains a no-visitors policy for carving projects, but as word of this totem pole spreads, other carvers, museum personnel, family members and the occasional outsider drop by the carving shed. One morning, a group of preschoolers, teachers and parents comes for a field trip. Chip gives a brief explanation of what the project is about and tells the story of the pole. He cautions the children about the sharp tools, then invites them to look at the figures. Moving the length of the pole, their small hands reach up to touch the wood and feel the emerging roundness of gigantic arms, legs and faces.

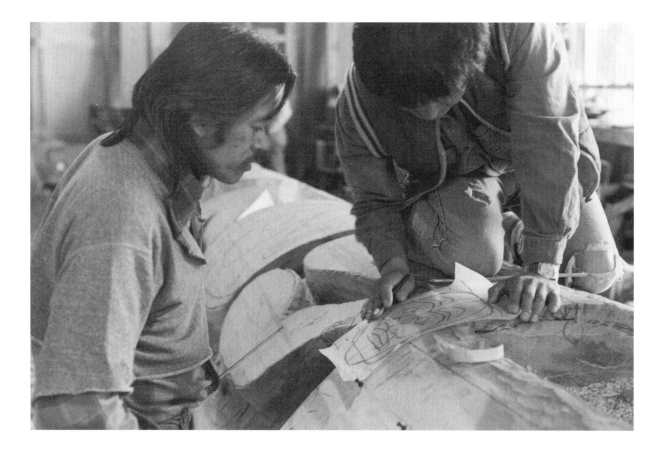

"This is going to be your
signature. And when you
walk through the pole,
you're going to say, 'I
did that!' So make it
you," advises Norman.

THE SIGNATURE FACES

30 April

Although each carver does most of the work on his own assigned piece, from time to time the others lend a hand. Chip talks about wanting everyone to "touch" all the pieces. Only one carving assignment that Norman makes is to be exclusively each carver's individual work—the signature faces.

Norman's drawing of the totem pole shows four small human faces ringing the ceremonial doorway. They peep around the edge, their hands grasping the cedarbark rope. Now that the pole is progressing well, he directs Chip, Hammy, Wayne and Isaac to each design and carve one face as a personal signature piece. "You guys can do your own faces, whatever you want," Norman states. "The main thing is I want you guys to put your own self into it. This is going to be your signature. And when you walk through this pole, you're going to say, 'I did that! I remember how I carved it. I remember what I had in mind when I did that.' So make it you."

Over the next few days, the carvers think about their signature faces. Like the add-on pieces, these small human faces will get concentrated chunks of time, but the carvers must integrate this work with their other duties on the pole. Chip is the first to choose a location for his face, claiming the spot on the pole's upper left-hand side with his grease marker. Isaac takes the place below his uncle's, writing "mine" on the cedar wood. Hammy chooses the position on the pole's upper right-hand side for his face, and Wayne the lower right spot.

Hammy begins drawing his face outline right away. Norman comes over, advising, "That's a real small face for such a big pole. Do it again, and let me look at it."

For several days, Wayne has been noticeably withdrawn. He has made no effort to begin sketching his signature face. Norman is quick to sense that something is wrong and asks him straight out, ''Wayne, I'm awfully worried about you. You're so quiet. What's happened?'' Wayne does not answer but manages a smile.

Hammy whistles bird calls that ease the silence. Looking up from reworking his face, he attempts changing the subject. With mock seriousness, he declares, ''I want sort of a smile . . . maybe a smirk.''

Chip picks up on the humour. ''You mean one of those satisfied 'all-knowing' smiles?''

Hammy nods. ''Yeah! Maybe a leer!'' From various places along the length of the pole, the rest of the crew joins in the laughter.

Joking and lightheartedness allow the carvers to relax. Sometimes, one of them will simply put down his tools and walk out into the surrounding trees. At other times, lunch or a cup of coffee, a pause to sharpen tools, a quick look through the day's newspaper, or a few minutes to remove slivers provides enough of a breather.

Eventually, Norman draws a sample signature face to demonstrate size, proportion and placement of features. He also helps the crew members to position their faces, leaving room for each figure's hands to clutch the carved rope that will outline the doorway. Because these faces are placed sideways, they run across the grain of the wood, a challenging assignment even for more experienced carvers. Some of the crew members trace the entire face onto the wood, but Chip uses Norman's technique of drawing one side of the face first and then matching the other side.

Once all the signature faces are drawn on the wood, Norman comes in to discuss them. The carvers gather around with their lunches, while he redraws lines and moves features, explaining as he goes.

As the rest of the figures on the pole progress over the next several days, so do the signature faces. Even in the rough stage, the four faces already show considerable differences from one another.

Norman returns to critique the roughing out of the features. With the crew watching, he first defines the lines he will recut, then gets busy with a small adze. When he finishes, the rest of the carvers resume working on their faces with new vigour and understanding.

When Norman is not teaching, Chip steps in with technical advice. He explains that because the grain of the wood runs across rather than up and down, ''You can't chop like you normally would. When the forehead has to go down, you have to adze from left to right. If you cut against the grain, you're going to split something off that can't be replaced.''

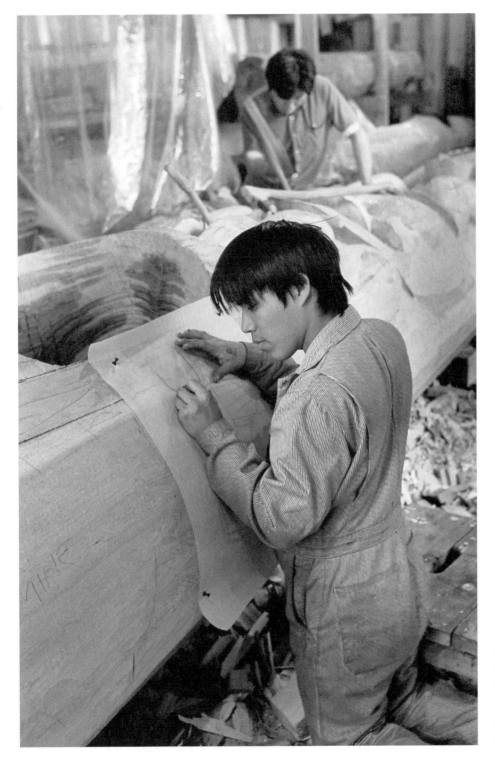

All the signature faces start with the same proportions, but individual carving styles and ideas soon make them distinctively different.

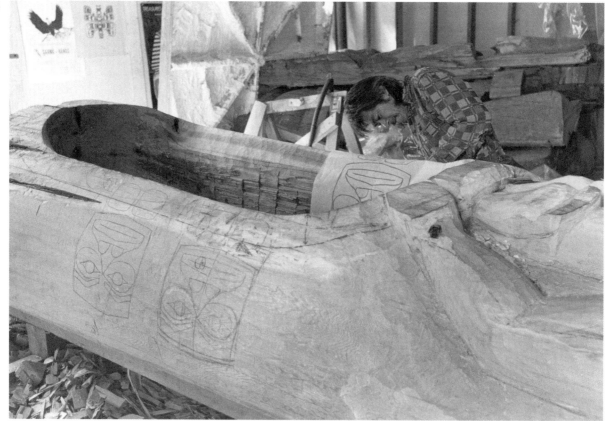

Hammy begins his
signature face. Chip's
and Isaac's faces are
already drawn on the
opposite side of the
neatly adzed-out
doorway.

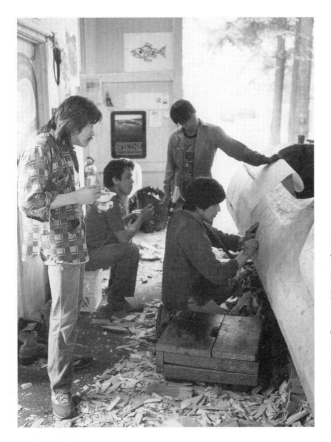

Even lunchtime is worktime.
The crew eats and watches
intently as Norman redraws
lines and moves features.

Carving faces in this
position is a challenge,
particularly because the
wood grain runs across the
faces rather than from top to
bottom.

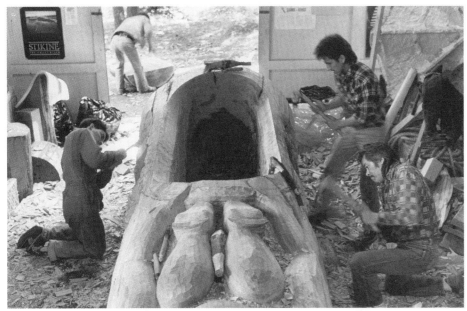

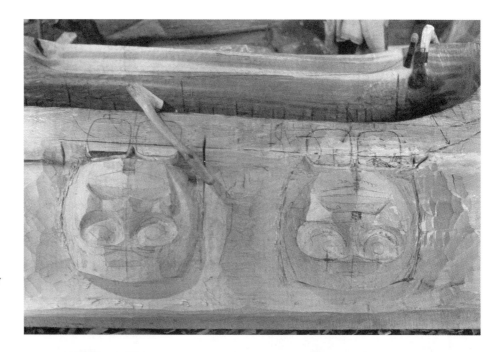

With only head shape and eye cavities clearly defined, there is already considerable difference between Isaac's and Chip's signature faces.

On the other side of the doorway, Hammy and Wayne's faces also have their own individuality.

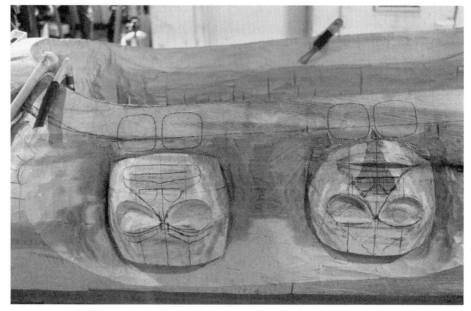

The crew also begins taking out some of the background wood surrounding the doorway. That procedure helps to define a raised section that will become a carved cedarbark rope, ringing the doorway. Early in the planning stages, there had been talk of affixing a real cedarbark rope to the doorway, but the carvers realized it would have to be replaced regularly, so they opted to carve something permanent instead. Although it is still rough, for the first time the doorway looks like an integral part of the rest of the pole.

Satisfied with the crew's pace and progress, Norman directs his energy to a personal project. Outside the carving shed, he begins work on a huge 42-inch Moon mask inspired by the smaller Moon figure on the pole. First he chainsaws a huge round of wood off the slab that was cut off the butt end of the log. Then he flies at it with his heavy adze.

When the crew members are ready for a break, he calls them to come outside and take a look at the roughed-out features. Together they critique the mask, enjoying the chance to give their teacher a hard time. Norman talks about proportion and placement of features. After the break is over, he continues on the

Evaluating Norman's large Moon mask, the crew members enjoy mimicking their teacher's critiquing style.

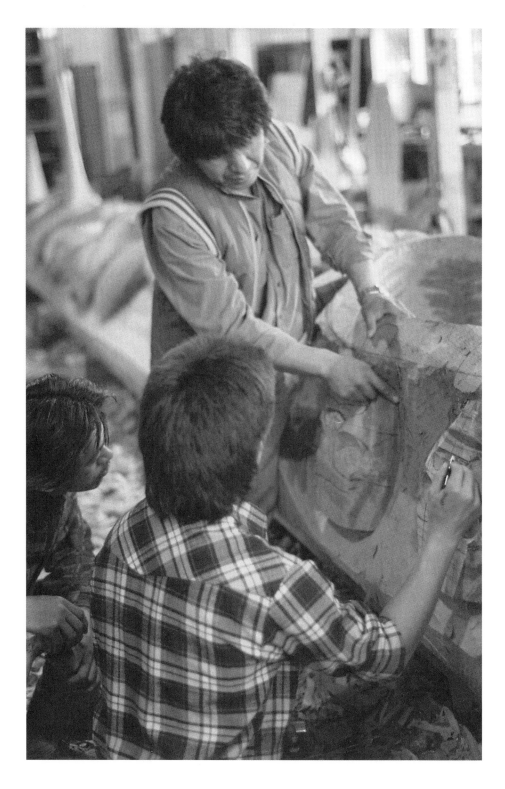

Norman continually
evaluates the signature
faces as they progress.

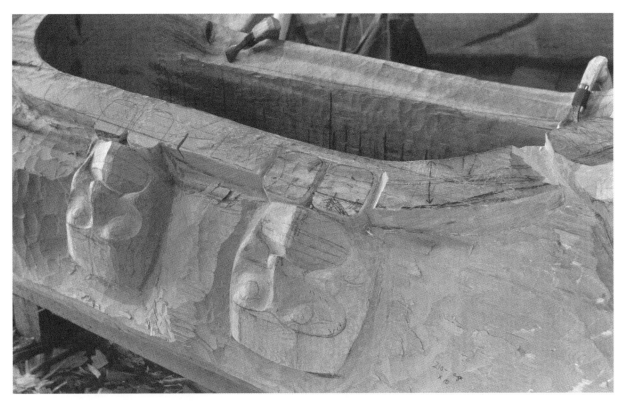

huge face; the crew members go back to work on their small ones.

Each signature face is paired with two hands that grip the ceremonial cedarbark rope around the door opening. At first, the hands are just pencilled on the wood as two rounded-off squares, but soon the carvers begin cutting and shaping individual fingers. Hammy makes a mistake as he carves four fingers on one hand and five on the other. "I remember the day he looked at it and realized what he'd done," Chip recalls. "You must have been talking more than you were paying attention," the foreman gently chides. Hammy covers the mistake by shortening one of the fingers into a thumb.

When Wayne's face develops a split in the wood, he decides not to alter it and instead incorporates the split as part of a tongue sticking out. "Individuality is what Norman wanted," Chip says, smiling. "He didn't want any copies."

"Norman surprised me on the hands," Chip declares. "I hadn't realized they were going to be there. I mean, they're not really hands, they're just fingers. They're Norman's insight, a little fooling around thing that he likes to do. You know, 'Let's just put a little bit of the hand peeking over.'"

Isaac adds, "That's what makes him Norman."

Chip agrees. "That playing around makes him different from anybody else."

As crew members cut away the background wood, the signature faces become more prominent. The process also begins to define the carved cedarbark rope around the doorway.

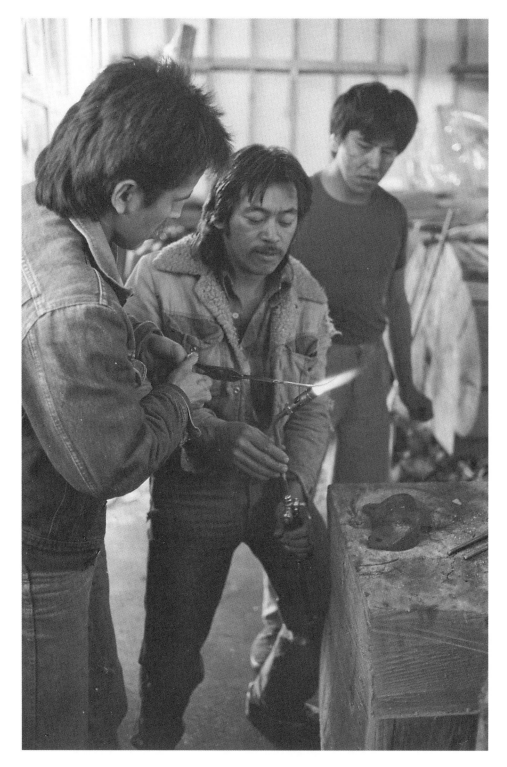

A curved knife blade
should be hard in order
to keep its edge, but not
brittle. Only the upper
side is sharpened.

THE END *of the* ROUGHING STAGE

7 May to 16 May

With the exception of the Wolfcub, the entire pole has now assumed a more round-ed, sculptural appearance. As the carvers range up and down the pole, they are comfortable with their tools and assignments. Blisters have long since hardened into leathery calluses. Band-aid consumption has ceased, but Isaac jokes that is only because the next one to cut himself has to buy a new box of Band-aids.

"This week is the end of the roughing; next week is finishing," Norman an-nounces. "So go on with what you're doing, complete the roughing stage, but be ready for it." Then he asks the question that Hammy, Wayne and Isaac have hoped to avoid. "Do you all have your tools?" The crew reveals the halting progress on the array of straight-edge and curved knives they've been working on after hours. They are also trying to finish up their regalia designs. "Well, this is last call," Norman reminds them. "We're all going to be working on finishing next week. There'll be no heavy work, so you might as well leave your heavy tools at home."

Chip laments the lack of a proper forge for toolmaking, but the carvers are making do with a grinder and an acetylene torch as they work on their knives. For knife blades, Chip favours converting metal-cutting files and teaches his crew how to take the temper out of a file by heating it red hot with the torch. Then the file's grooves are taken off with the grinder, a process Chip refers to as "cleaning the blade." Next he has them draw out the design for the narrow blade of the knife and begin shaping it. "It takes me about six hours from start to finish to make a set of knives if I have the equipment—grinder, file and idea. You need

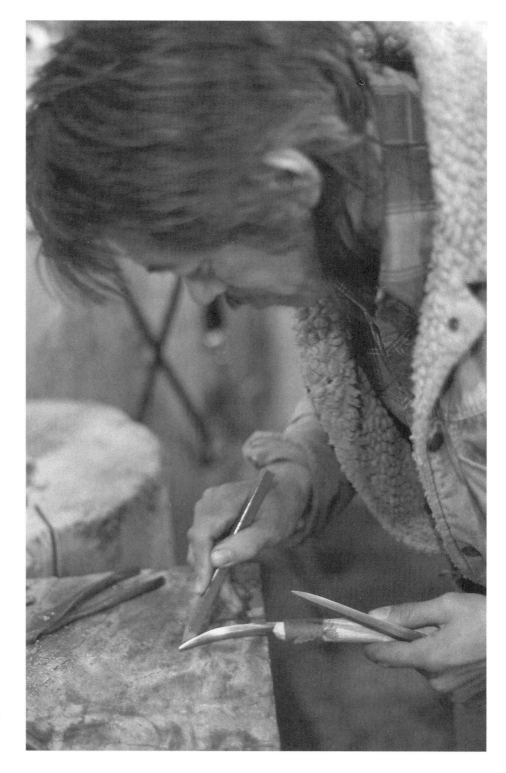

The narrowness of the curved blade helps the carver work small areas and facilitates any scooping kind of cut.

a good steady pace, and you don't stop until they're shaped. The fun part will come when you start bending the blades for your curved knives.''

When the carvers have their blades ready to bend, they help each other with the process. One holds the torch steady, while the other heats the blade red hot. Satisfied with the temperature, the carver then bends the heated blade against an anvil until he gets the degree of curve his design calls for. When the process is finally complete, his smile of relief is heartfelt and shared by all. Next, the wooden handle is shaped, and the blade is secured to the handle with twine. After sharpening, the knife is heated once again to put the temper back in.

Once the tools are finished and put into use, keeping them sharp is essential. Chip notes that this lesson needs to be taught and retaught. ''If you're strong and the tool is dull, you'll make that wood work, but it won't look the same, and it won't feel the same. You'll be tired, and you'll be overworking your adze and overworking the wood. It's easily ripped, and the carving doesn't have that control and quality. It's the same with the knives, especially in the finishing stage. When you get down to the finish adzing, you want to make sure you don't have a nick in your blade or everything you've finished will have a nick on it.''

Chip laughs, admitting that there's another reason for sharpening tools. ''When I first started with Norman, I used to sharpen my adze whenever I'd get tired. He noticed that I'd sharpen it sometimes seven, eight times a day, just so I could rest!''

Often, Norman works ahead to the next stage on one figure, letting it serve as a teaching device or reference for the other carvers. They watch him work, then use the same techniques they've just observed to bring the other figures along. Only a few pencilled lines remain. Most figures, such as the Human's face, are ready for finish work. With a carefully sharpened chisel, Hammy smooths and rounds a leg. ''Whether we want to or not, we're starting to clean up,'' Chip states, referring to the finer finish work.

Norman calls the crew together for yet another critique of the pole. The Raven's beak already looks like it belongs to the pole, even though the bird's cheeks have yet to be shaped. Norman eyes this topmost figure carefully. As his fingers trace the Raven, he begins a series of cryptic instructions, a kind of verbal shorthand for the crew members. ''Let's not go that far back. This is set right here, so join up with this. Kind of dive in right there. This one goes in more, see? Flow with this line. It's an existing form, an existing shape, so take a dive here, come up, and join up with this and then round it off.

''Pay attention to the way these cheeks are taken out of the Raven. It's interesting. You can use it on every kind of bird—Thunderbird, Eagle, Raven—it's all the same. You change the beak a bit, you change the expression for each creature. But putting on the beak, putting the cheek in, is all the same.''

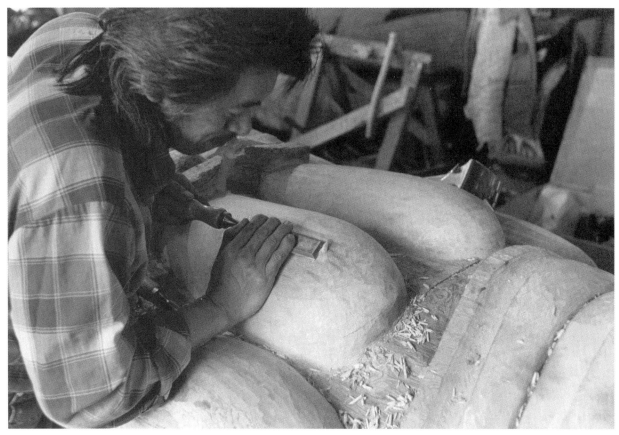

Hammy uses his standard
one-and-a-half-inch
''working chisel''
horizontally to render a
smooth surface finish.

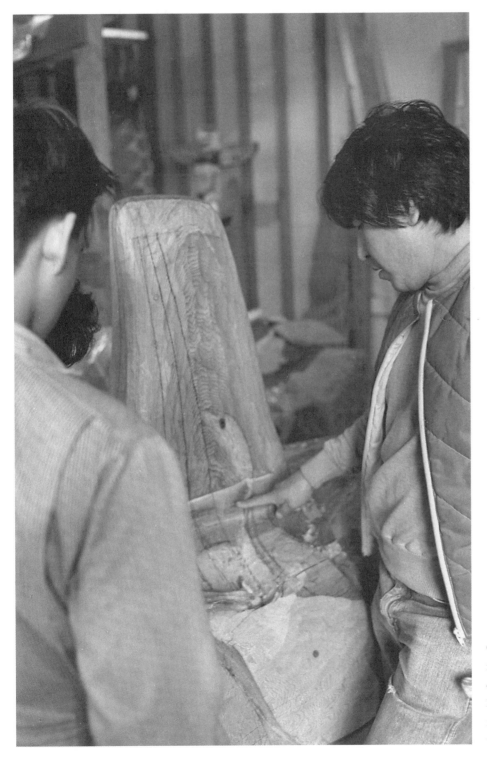

Once the Raven's beak is
firmly in place, Norman
explains how carving the
long mouth line will help
integrate the beak with
the rest of the pole.

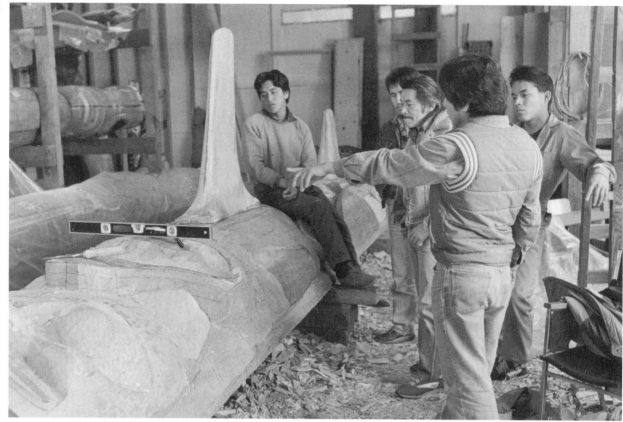

The Whale's fin is now
smooth and streamlined,
but the bulky base is still
a problem.

The crew follows Norman down the pole to the Whale. Viewed by itself, the fin looks streamlined. But on the pole, it still does not flow into the body of the Whale. Some careful cutting seems necessary to sculpt the fin's base. Hammy offers to help Wayne with this delicate chainsawing, so Norman addresses his instructions to both of them. "The only reason I left the lip of the fin that thick is for strength," he explains. "Now we're coming down to the finish line, and it can be thinned out so that it will follow the form of the body."

"You want this to taper right down this way, eh?" Hammy asks, feeling the lip of wood at the base of the fin.

"Yes," Norman confirms. "Remember that the blowhole is going to go right there. It's got to be big enough so that it goes with the fin, but a little bit smaller than the eye so that it doesn't take away from the strength of the eye."

During the next week, Hammy and Wayne will work at thinning the lip as well as carving other parts of the pole. "Around that area on the front and back of the fin, the wood is hard, cross-grain, eh?" Wayne explains. "It was hard cutting that cross-grain and that bottom was getting pretty thin. I was scared when I took it off with the chainsaw."

Norman backs away for an overall view of the Whale. Initially, he planned that Chip would carve a complex design into both the Whale's side fins and the Raven's wings. But as the pole progresses, Norman and Chip agree that elaborate detail would detract from the rest of the work. Instead, Norman suggests a simple design for the side fins and tail, one that will not take attention away from the dorsal fin.

As the beak and fin get closer to completion, Chip reminds his crew to start thinking about any small personal items they might want to place in the slot cavity when each add-on piece is cemented in. This small time capsule is a personal tradition of Norman's; the only stipulation he makes is that nothing metallic that could rust and discolour the wood gets sealed into the pole.

The crew is working confidently now, only occasionally needing guidance. Norman uses their conversation as a barometer to assess how they are doing. "In the beginning, they hardly talked at all. Now, halfway through the pole, half of the talk is totem pole; the other half is girlfriends!" He laughs, noting that the younger men consider Hammy the experienced "old man" of the crew and are regularly after him to tell stories and pass on advice.

Isaac follows his father's suggestions over the next few days, shaping the Raven's beak so that it flows into the face. When that is done, he fixes the beak into position with tar and dowels. Chip explains that roofing tar is a messy but effective adhesive and that the ease of purchasing a can of it is a timesaver over gathering more traditional substances such as spruce pitch. Most importantly, tar is watertight and will keep out moisture that causes rot and erosion. When the beak is

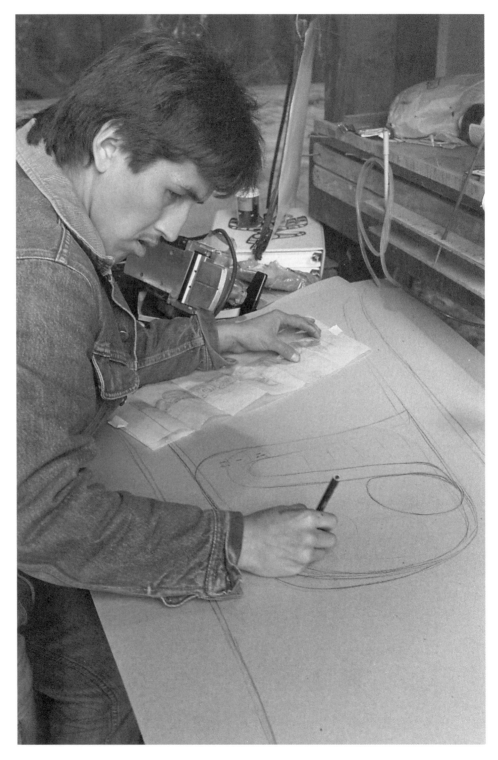

Wayne tries sketching a design to be cut into the Whale's fin, based on Norman's original drawing of the totem pole.

secured, Isaac moves on to finish cutting the Raven's eyes, cheeks, mouth or beak line, and nostrils.

The Whale's head is beginning to take on a more sculpted shape. The next step is for the teeth to be cut back further, creating a lifelike lip that curves around them. Eventually Wayne begins the design for the dorsal fin. "The first drawing we used was really Chip's design," he explains. "I drew the design, but he helped me along; I didn't know a thing about design, about drawing humans." But when Wayne transferred the design onto the fin, Norman was not happy. "I guess Norman and Chip just had two different ideas about it. But Norman's the master carver, so we went with his."

As Norman surveys the pole, he notices marks on it from someone's boot. It prompts him to give instructions for the cleanup or finishing stage soon to come. "Once we start cleaning up, if you have to climb over the pole or if you want to see what you're doing from above, you have to have a cloth or something to stand on. You can't stand on the wood any more. It marks very easily. Get that habit now." He reiterates, "Once we start cleaning with our knives, we don't want to have to go over it again. We want red wood from now on."

Chip elaborates on Norman's reference to "red wood," telling his crew that the pole's final finish of tiny knife strokes must stay a uniform colour. "You'll notice that once you get your finishing work on, if you damage it, the whole area has to be fixed. If you just fix the one spot, it's going to show."

Norman agrees. "Once the wood starts to change colour and you take one little section off, you'll notice that section all the time because it'll be a different colour. So consider that from now on. If you have to cut in deep, check with Chip or me. Whatever you do on any part of this pole, if you've made a new cut, that's the cut that's going to stay there forever."

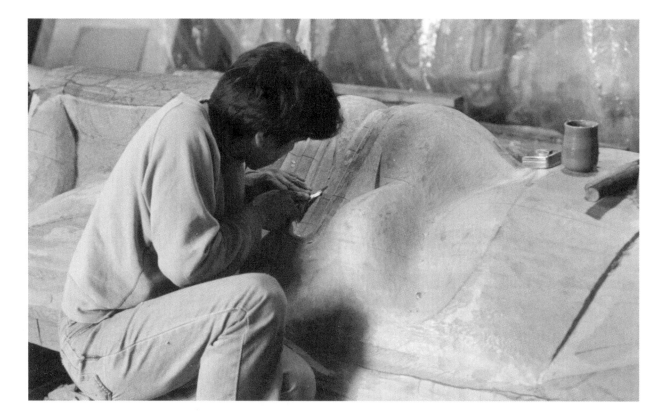

The carvers rely on their
curved and straight
knives for much of the
finishing stage. The
heavy work is over; now
come long hours of fine,
careful carving.

THE FINISHING STAGE

17 May

A warning sign tacked on the base of the pole warns visitors not to sit or stand on it. Nearly two months into the project, the crew members need no sign to remind them that their carving is at the finishing stage. They are putting in even longer hours in order to work on their regalia and finish making their tools.

Over the next few hectic weeks, the women who are sewing the regalia almost have to run after the carvers in order to take their measurements and make fittings. Despite prodding, the crest designs are still slow in materializing. For inspiration, Hope takes both the designers and those that will be sewing the regalia out to the Museum of Anthropology. Curator Betsy Johnson takes out drawer after drawer of old button blankets, tunics and dance aprons for the group to study.

Isaac declares, "We're learning a little bit of everything on this pole. It's all one great big lesson! One thing leads to another; you can't do this without doing that. We're also learning the tradition and the culture—especially Wayne and I, making our regalia, finding out who has what responsibilities and so on. We're learning about each other, something about being a family. There's a lot of tension, but we're family, and that's one of the reasons we're sticking together. We didn't take much note of it in the beginning, but this pole is a family pole, and it's felt closer than other projects."

He pauses to think, then adds, "I don't think carving this pole is bringing *back* the culture; for me it's carrying it on."

Wayne has reached a similar conclusion. "There's a lot more to carving than just working on the wood—like the dancing and the singing. I'm just starting

to realize all the things I was missing out on all those years I was just wandering around, hitchhiking around. Chip told us, 'Even after you just start this pole, you're not going to be the same. It's going to be a big part of your life.'"

It has become a part of life for Hammy's young son, Mark, who often spends his days playing outside the carving shed while his father works inside. Hammy has grown confident enough to begin his own carving project at home, and brings in the half-Man, half-Bear mask for Norman to critique.

Both Chip and Norman are aware of the growing commitment to the project and to each other as family and as carvers. Chip feels, "My biggest accomplishment on this pole is to mould three individuals into a crew. Everybody's struggling, and now and then one breaks away, but in the end we've all come together. Now that it's almost over, I feel pretty huge inside. It's like playing on that team you've always wanted to play on. Not being the star, just being on that team."

The rock music is slightly lower in volume now, since it no longer has to compete as often with chainsaws and heavy adzes. Close up can be heard the scratchy sound of a ribbon of cedar curling away from the blade of a curved knife.

The way in which these knives are used is as distinctive as the tools themselves. Held palm up, curved knives are pulled in towards the carver. The short, repeated cutting stroke relies primarily on wrist action. Even experienced carvers occasionally cut themselves with this pulling-in method, but it provides more control than the customary North American method of holding the knife palm down and pushing it away from the body.

Since most of the figures are getting their teeth worked on, the carvers joke that this could be called the dental stage. Norman sips a cup of coffee and gives a few pointers as Chip evens the surface of the Bear's face with a curved knife. The patina on the creature's great face comes from the delicate, repeated strokes of his curved knife or small chisel. Sandpaper is never used on totem poles. Chip draws in the teeth, carefully straightens the lip line, then cuts tooth after tooth.

Moving from teeth to feet, Norman takes a sharp chisel and begins rounding individual toes on the Human's upturned feet. When he is ready to move on, the Human's limbs are marked with his characteristic trademark of ankle bones and wrist bones.

Wayne is doing his own dentistry on the Whale. His confidence in using the chainsaw has grown with experience. Now, he can chainsaw in even the delicate line between the Whale's upper and lower teeth. "By the time I got around to the teeth, I had a pretty good feel for the wood. I wasn't so tied up in knots. I was beginning to get some confidence, and I had a better idea of exactly what they wanted." Using a straight-edge knife as well as chisel and mallet, Wayne undercuts the lip first. Then he shapes each tooth and delineates it with a V-shaped

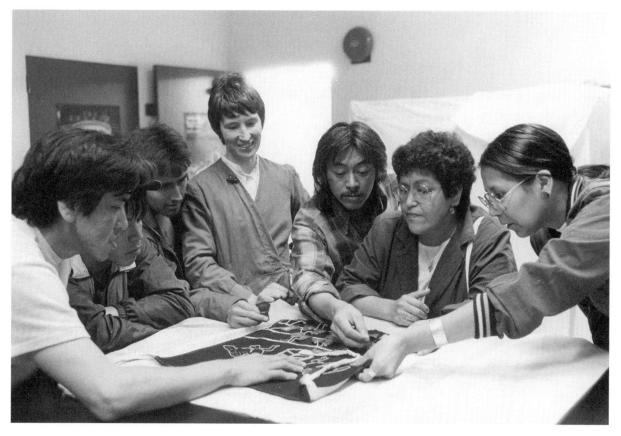

Following Norman's way of teaching, Hope takes Chip, Isaac, Wayne, Hammy and Barb Morrison to the Museum of Anthropology where curator Betsy Johnson shows them vintage regalia.

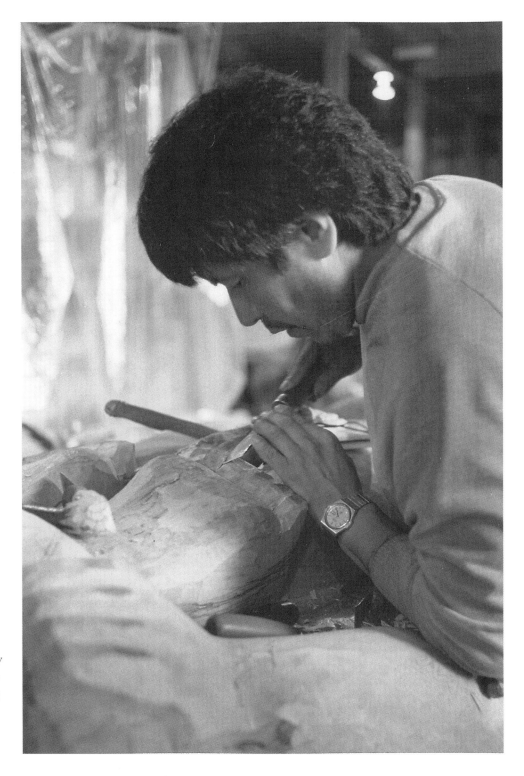

Norman characteristically gives a human quality to any creature's hands and feet—fat pads on feet, chunky toes, ankle and wrist bones.

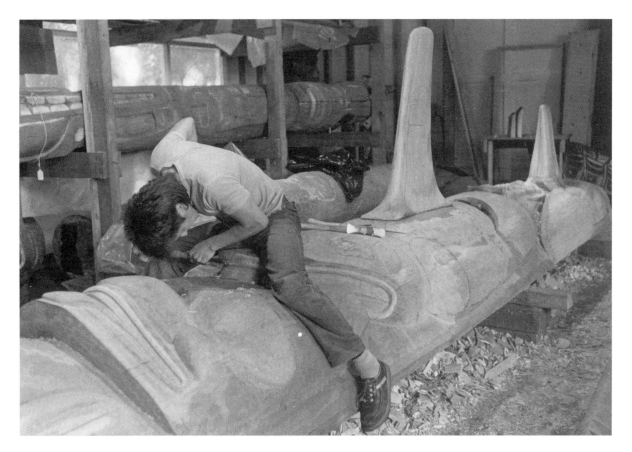

groove. The crisply outlined teeth leave no doubt that this Whale is taking a good-sized bite of Bear.

As Wayne undercuts the Whale's lip and defines its teeth, he works with confidence.

20 May

One day, Norman makes an announcement that temporarily bumps work on the totem pole to the back burner. He has accepted an invitation to make an appearance at the first Asia Pacific Festival in Vancouver, scheduled for 8 June. Norman and his crew will arrive at the site clad in regalia and paddling canoes. Then they will join a larger group of Nisga'a to sing and dance.

With only three weeks to prepare for the festival, there is a sudden flurry as Norman's three hand-hewn canoes are brought into the shed to be repaired and painted with new hull designs. Norman calls a family meeting at the carving shed to discuss the preparations for the performance. He wants blue tunics completed for all the crew members to wear. Each carver will have to make his own paddle, and the entire group will need to learn and practice a Nisga'a song. As

soon as the meeting is over, Hope pulls out her tape measure and begins taking down sizes.

Work on the totem pole does not stop entirely, however. Norman begins carving the cedarbark rope that is to encircle the ceremonial doorway. Working alone, he first draws a series of slanted, parallel lines around the entire lip of wood that outlines the doorway. Then he takes his chisel and begins cutting deep ridges that appear to spiral around the lip. Over the next few days, curved knife work will finish the rope to the same smoothness as the signature faces.

Chip has finished up the Bear's smooth tongue. Next he tackles the fingers of the Moon face figure, first outlining and then rounding each one. It is quiet, satisfying work.

There are still chainsaw marks in the doorway to smooth out, and Isaac begins that job with his adze. Since he is cutting against the end grain, progress is slow, but the entrance must be smooth to both the eye and hand. For a break, Isaac switches to chisel and then curved knife in order to continue the finish work his father started on the cedar rope.

1 June

Norman is well aware of the relentless hours his crew has been putting in for two months, and he is pleased with their progress on the pole and the canoes, so for a few days early in June, the crew all take a trip to Seattle. Part of the time they spend in museums; curator Bill Holm takes them into back rooms of the Burke Museum to look at canoes, paddles and other carvings. Part of the time the crew members just relax and have fun, dancing, shopping and eating. Chip recalls, "We helped each other with money; we were a crew. When we came back, we were all laughing about one thing or another."

5 to 8 June

Back in Vancouver, activity quickly resumes. There is finish work to do on the pole as well as paddles to carve for the canoes. Late in the afternoons the crew practices singing and drumming. Hope shows up with an armload of basted tunics, ready to check the fit.

If regalia did not seem so very important before, the group's appearance at the Asia Pacific Festival changes all that. Clad in matching tunics and leggings, the carvers make a most impressive entrance, paddling three hand-carved and painted cedar canoes. Norman wears a striking Beaver mask and carries his drum. The performance goes well. The event is not only an exciting day off for the crew and their extended families but is also first-hand proof that regalia imparts a strong sense of identity and pride.

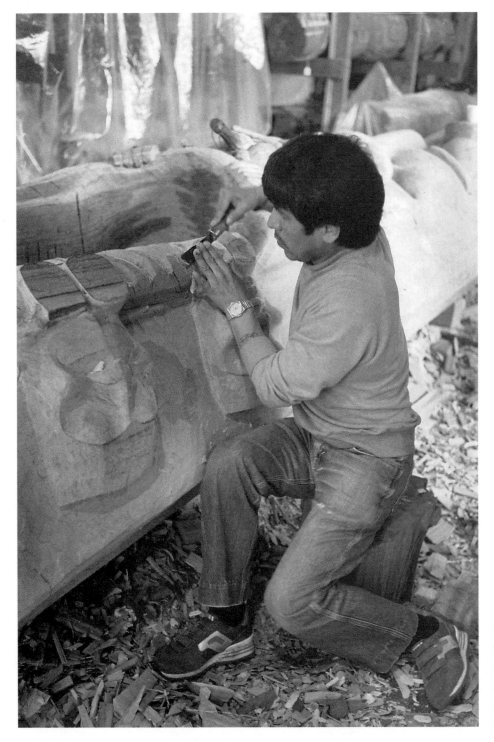

Norman uses a chisel to begin defining the cedarbark rope. He scores the wood diagonally and then sculpts each section round.

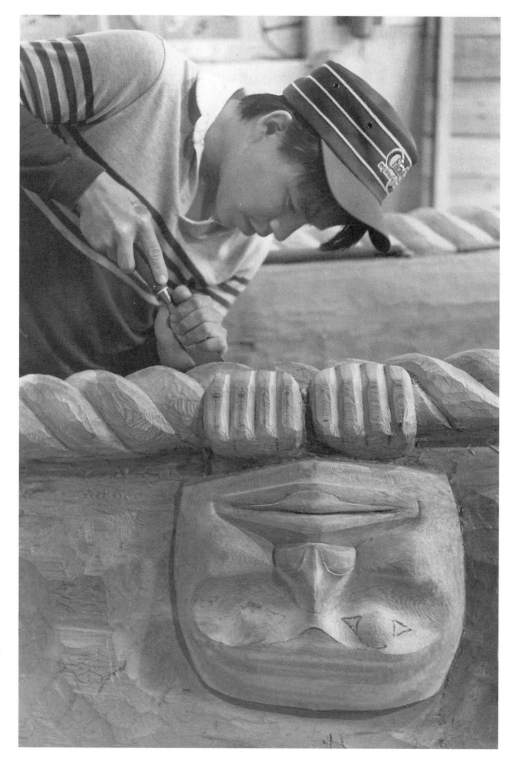

Isaac uses both chisel and curved knife to finish the cedar rope. The inside of the doorway must also be adzed smooth to the touch.

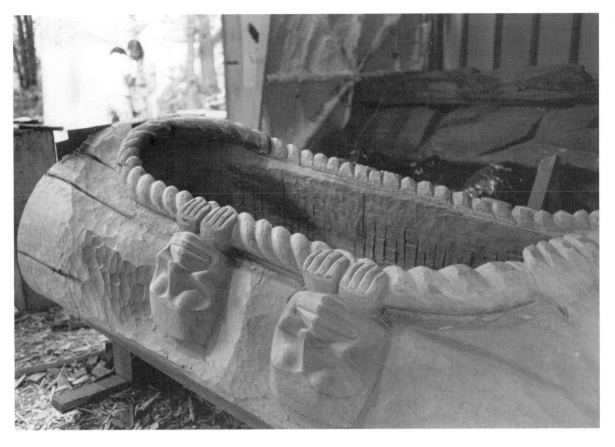

As the rope progresses, so do the small hands. They serve to anchor the signature faces to the pole, an example of how Northwest Coast design elements flow together.

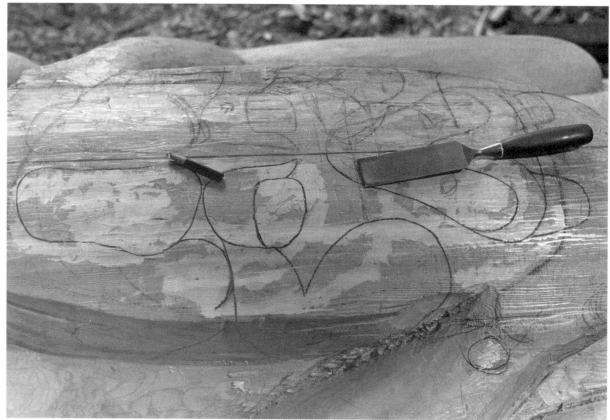

The rest of the pole nears completion, but Norman's signature piece, the Wolfcub, has not been touched.

10 June

Norman prefers to leave his poles unfinished, allowing nature to fade them to a soft, silvery grey. Modern poles are sometimes given a coat of linseed oil to help keep moisture in the wood, but he warns it can turn the wood dark. Occasionally poles are also treated with a chemical retardant to inhibit insect damage or bacterial growth, but Norman notes that red cedar contains natural oils that resist rot, allowing most totem poles a lifespan of seventy-five to a hundred years, even in the damp climate of the Pacific Northwest.

Originally this pole was to be painted, like Norman's early poles, but he ultimately concluded that paint would detract from the pole's strong design. Howard Green, director of the Native Education Centre, agreed with Norman's advice when he saw the building going up. "The building itself was attempting to be very natural," he notes, "and to paint the pole would have been incongruent."

Once the decision is made to leave the pole unpainted, the crew begins cutting V-shaped grooves around all the eyes, eyebrows, and nostrils. These wider, deeper incised lines, rather than colour, will serve to accent features.

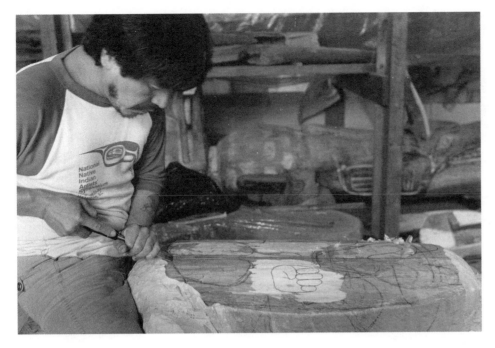

When he is finally ready to tackle his signature piece, Norman sketches the basic design. Then he positions upturned feet and childlike paws.

At this point, only one figure on the pole has not had any work done on it, the Wolfcub that Norman claimed as his own piece early on. Chip recalls, "I was nervous because I thought I was going to end up doing it. But it was amazing, because when Norman got going on that cub, he really went."

Indeed, one afternoon Norman comes into the carving shed, cleans Chip's drawing off the surface of the wood and sketches his own idea for the Wolfcub. Next, he transfers hand and foot patterns. With his adze, he begins rounding the rough-cut wood, then draws on the limbs.

When the figure is complete in Norman's mind, he begins cutting away the wood. Soon he is ready to sculpt the Wolfcub's face, hands and feet. Within a day or two, he is working on the final V-shaped grooves that outline eyes and eyebrows, nose, teeth and ears. In the few afternoons that it takes Norman to carve his signature figure, he demonstrates all the techniques the crew has learned.

Watching the entire process, Chip says, "When Norman flies at it, he doesn't talk too much. He doesn't draw. He just thinks. He decides whether it has to be done with an axe, chisel or an adze, or whether he's wasting his time with a chisel and should take a saw to it."

Chip adds, "I try to grasp everything Norman teaches me, everything he says, everything he wants me to do. When he wants me to look at something, it's not because he wants my valued opinion. He wants me to learn how."

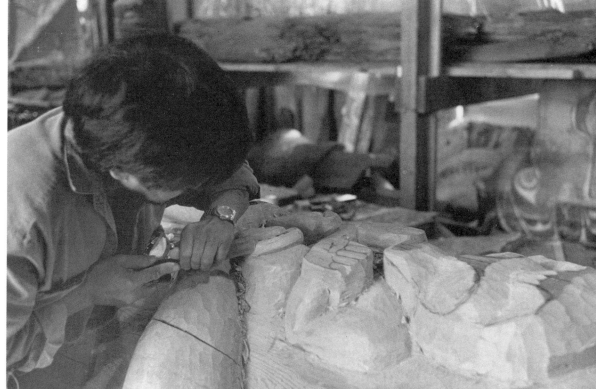

With controlled strokes,
Norman adzes away
background wood,
popping out the limbs
and head. Next he shapes
toes, just as he did on
the Human's feet.

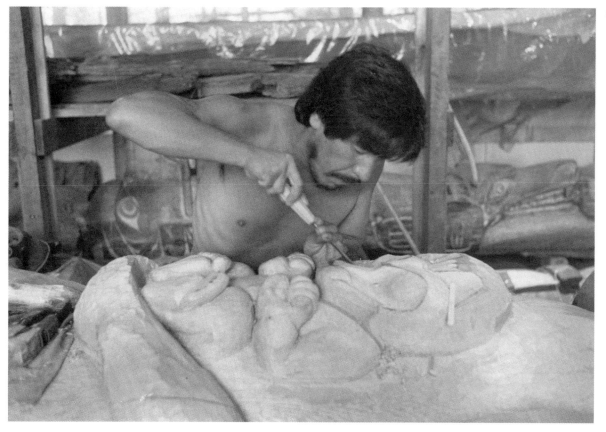

Norman chisels the
Wolfcub's facial planes,
then follows with his
curved knife for finer work.

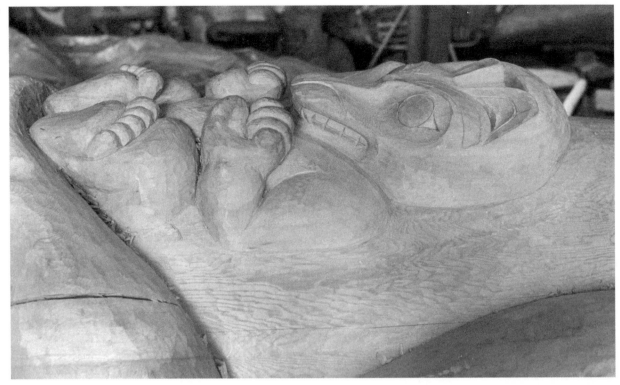

Nearing completion, the Wolfcub definitely possesses a babyish, roly-poly whimsical character.

12 June

Work is going on up and down the length of the pole. The large ovoids on the Whale's upturned tail are cut. The design for the Raven's wings is drawn on, and the cuts are begun. Isaac is working on one side of the bird, Chip the other. Besides that, Isaac is doing the eyebrows for the Moon figure and the Raven. Chip is also working on the Moon figure and designing the Whale's side fins. Hammy is cleaning up the cedar rope. Wayne continues shaping the Whale.

Meanwhile, the women of the family are translating Hope's skilfull instructions to making their own button blankets. She also talks to them about their role and responsibility within the larger family. "It's the males who are in charge. It's always been like that and it always will be. I find myself answering to my male family, even though they're sometimes younger.

"I'm strong, too. Sometimes I have the knowledge because I talk to my mother and ask questions a lot. Mom isn't here in Vancouver half of the time, so it's just up to me to push and pull. My responsibility is more than just the regalia. You need to give these guys ideas, give them a sense of who they are. The regalia follows. It's a symbol, really, for what they stand for and what I stand for. It all comes back to who we are."

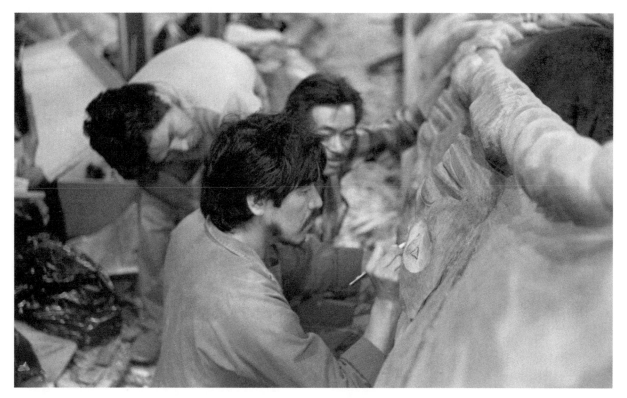

Norman gives some last-minute help with the signature faces before the carvers make their final V-cuts around the eyes. Chip says, ''I felt like we all did the pole, but these hands are *my* hands, this is *me,* forever and ever. I'm right beside my nephew, and my other nephew's across. We're hanging on for dear life, trying to do what Norman's teaching us—and it's ours.''

Wayne gives the entire surface of the Whale a smooth finish of tiny knife strokes. When the eyes, ovoids and blowhole are carefully redrawn, Wayne goes to work V-cutting around them with a straight-edge knife. Finally, he gently scoops out the blowhole.

Norman has been struggling with the problem of getting the fin attached to the Whale so that it flows into the body but still keeps some strength in the lip. ''This problem came up primarily because of the shallow-cut pole,'' he states. ''It taxed my imagination to the fullest.'' Finally, Norman decides to use a router to countersink the lip of the Whale's fin rather than trying to cut it any thinner. Wayne traces the lip with a pencil, then carefully cuts out just enough from the pole so that the fin can be inset. Although the technique is certainly unusual, it works to maintain both the strength of the lip and the flow of the fin. Norman is pleased.

Norman helps to draw eyes on the signature faces, then shows how to V-cut around them with a straight knife.

A router provides an unusual solution to sculpturally integrating the fin with the body of the Whale while maintaining the piece's structural integrity.

15 June

With just thirteen days left before the pole-raising, Wayne begins a revised drawing for the dorsal fin. "Norman did a quick sketch on one side and told me to make it uniform, that's all. Then I transferred it on the other side," Wayne explains. "He ended up doing the whole design, actually, and I just made it uniform." Wayne cuts the face and hand design with a straight-edge knife. He finishes by taking away wood around the hand, further accenting it. Feeling his oats, Wayne shortens all of the long fingers except the middle one. The result is that the figure on one side of the fin gives a definite middle finger salute.

19 June

At last it is time to attach the fin permanently. Before putting the fin on the pole for the final time, the carvers each sign a piece of cedarbark and drop it into the small cavity. Hammy adds his Nisga'a identity card. Then glue is slathered around the sides of the peg, and the fin is carefully lowered into place. Norman has opted for a waterproof marine glue for the fin rather than the sticky black tar they used for the beak. He feels both should work extremely well.

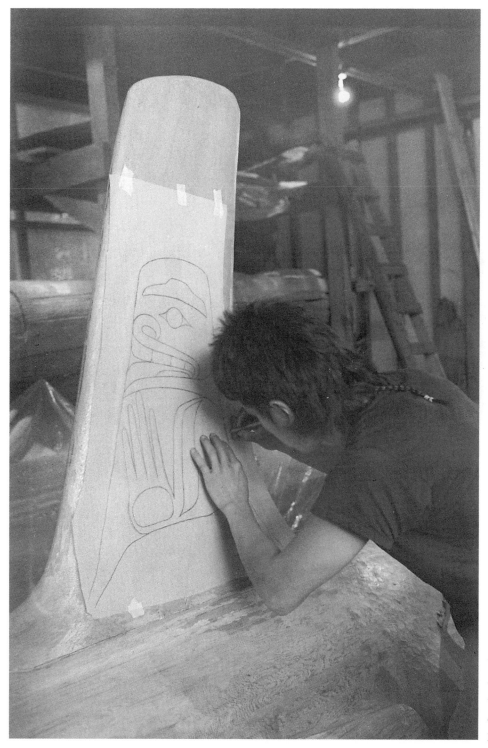

Wayne transfers Norman's
design onto each side of
the Whale's fin, then
cuts it into the wood with
his straight knife.

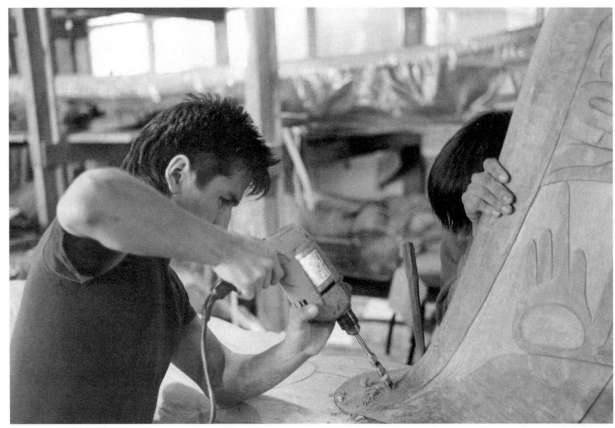

Wayne begins the process of securing the fin to the pole, drilling holes and inserting dowels.

The final step is to insert the four dowels that will anchor the fin in position. Isaac holds the fin while Wayne drills the holes for the dowels. "I figured out if I just drilled one hole after another, they might not match up if the fin moved a little bit, but I still went ahead and did it," Wayne explains in frustration. "I made one hole and didn't put the dowel in; I made another hole and was going to go for the third one, but Uncle Norman was right over there as soon as he saw me." Wayne glues in the dowels and finishes by cutting them off flush with the fin.

With the work nearing completion, Chip sums up, saying, "This is a great totem pole because it's taught all those guys exactly the way they were supposed to be taught—hands-on teaching. What makes this pole authentic or native is the feeling we put into each figure, our feeling for the story, our feeling for the use of the tools and the wood. We learn all these figures, why we can use these figures, why we're responsible to make this figure the way it is." Chip feels that completing the fin is an especially significant achievement for Wayne. "Wayne

didn't believe he could do that Whale, but he did it. And when he put that fin on there, it was like he was saying, 'Wow, I really *am* an Indian, I really *am* a Nisga'a.'"

The workdays are now stretching on until one or two in the morning. One late night in particular, Chip sees that his crew is finally too weary to do any more work and announces, "O.K., that's enough. Let's pack up." Silently, the four of them collect tools, load their backpacks, put the stereo away and locate the padlock for the carving shed door. Unexpectedly, one of the carvers climbs up onto a trunk for a last look at the pole. Suddenly, everyone is standing on boxes or climbing up ladders to get a look.

"For us, it was just work, until we all stood back and looked at it," Chip recalls. "Then everybody felt the same way. Wow, what a beautiful pole!"

As Wayne describes that memorable night, "That's when it finally hit us. This humongous piece of wood had turned into an art piece, and a 42-foot one to boot!" He pauses, then says thoughtfully, "It's an art piece that's going to be around for ages, and we did it."

Chip adds, "We missed the last bus that night. Tired as hell, we were ten feet tall walking home."

20 to 26 June

More family members are showing up at the button blanket work sessions. Pleased and relieved, Hope comments, "The family really pulls together at times like this." Sadie Tait travels down from Prince Rupert and helps out at a particularly large session, scheduled at the Vancouver Museum and Planetarium. Chip helps out by drawing a Wolf design for a vest that will be given away at the pole-raising ceremonies. Hope looks at the heads of carvers and seamstresses bent together in concentration. "This is more important than any family squabbles. Now they're finding out a little more about themselves. It's all part of the learning."

During one of the breaks in the last week, writer and naturalist Hilary Stewart brings out some cedarbark to the carving shed. Working in the early summer sunshine, she demonstrates how to braid cedarbark headbands, adding another piece to the carvers' regalia.

With less than seven days to go, a stainless steel plate is bolted onto the base of the pole as further protection against rot. Just before it goes on, the crew members all sign the base of the pole. Later, however, Isaac reflects, "I don't think we'll ever autograph anything again. Dad let us sign that, but after a while he thought it over and figured that our signatures were already all over the pole."

Hammy fires the entrance hole with a blowtorch to give it a harder finish,

Isaac and Hammy complete the scratchy job of cleaning the back of the pole, one of the final tasks.

then he and Isaac take turns at the unpleasant task of cleaning the back of the pole. Armed with an adze and eyes protected by goggles, each wriggles under the pole to take off the slivers on the back. It is scratchy work, and, when done, each emerges covered in cedar chips.

And then, finally, one night the totem pole is done.

"We just said, 'That's it,' and everyone packed up their tools for the last time," Chip recalls. "You leave the pole. Then the next morning you get out of bed late; you don't have to rush to work. You come, and you've got your best clothes on, and the place is cleaned up. But you still feel like working! You look at the pole and still see things you want to do." He chuckles. "You could keep on for two, three years, but then it would be a pile of wood chips. So you've got to say, 'That's it!'"

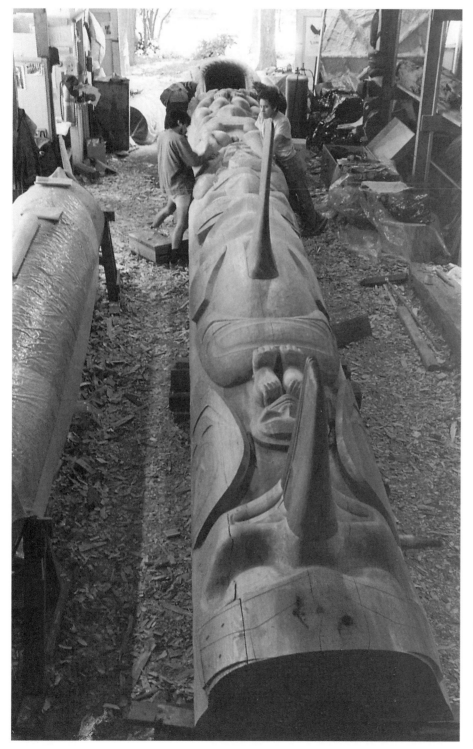

"For us, it was just work, until we all stood back and looked at it one night. Then everybody felt the same way. Wow, what a beautiful pole!" exclaims Chip.

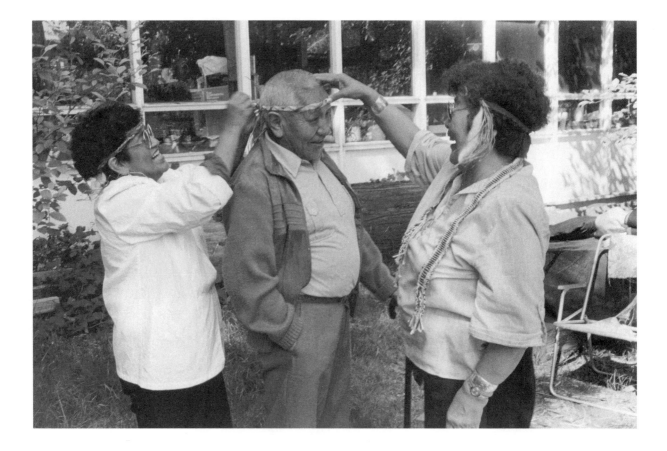

Completing regalia to wear at the pole-raising ceremony, Hope and her mother, Sadie, fit Josiah Tait with a cedarbark headband.

RAISING *the* POLE

27 June

Today, the totem pole will be moved out of the carving shed and trucked across the city to the new Native Education Centre at 235 East 5th Avenue. Tomorrow will see the actual pole-raising.

The crew's regalia is finally complete. Each carver has his own tunic, leggings, headband and button blanket, although some of the finish work on the blankets continues up until the last minute. Hammy's sister, Cecilia Martin, comes down from Prince Rupert and spends the night before the pole-raising sewing on buttons. Hope is pleased with the additional people who have shown up to help with the regalia. Confidently, she predicts a good-sized crowd will also lend their support at the raising ceremonies. "There's our large Tait family, but there's also the large Nisga'a family as well. Wherever you find Nisga'a, you'll find that they are a group, a family."

Chip and Norman have already explained to the crew that they are not allowed to clean up or carry the totem pole themselves, now that it is finished. However, it is still their responsibility to transport the pole to the site and raise it with appropriate ceremony. For this they draw on the support of the greater Nisga'a family and others, primarily urban natives and those who gather to witness the event. This tradition among northern groups such as the Tsimshian, Tlingit and Haida extends back to the days when one clan would hire another to carve their totem pole. The carvers and those who helped to move and raise the pole were always acknowledged and compensated or paid at a feast afterwards.

Norman says, "The carvers honoured the people with their work. Now it's

their turn to be honoured. I told them to act it, to feel it.''

By nine o'clock the pole movers start showing up at the carving shed. Their first task is to shovel and sweep up the thick carpet of wood chips that has cushioned and protected the blade of any dropped tool. The pole's doorway is covered over with a canvas to prevent its use before the raising and naming ceremonies.

Outside the carving shed, Tait relatives sit in the summer sun, visiting and working on last-minute cedarbark headbands. Sadie Tait and her daughter, Hope, are in high spirits as they fit one on Wolf clan chief Josiah Tait. Howard Green of the Native Education Centre arrives, as do television crews and newspaper reporters. Some interview Norman while others take photographs of the pole. The carving shed has temporarily surrendered its quiet, sheltered atmosphere to the growing crowd.

Norman is clad in a deerskin tunic, dance apron, leggings, moccasins and newly fashioned cedarbark headband. Reva Robinson colours her hand in order to put four red stripes across one side of Norman's face. He explains that red is the colour of life, a suitable choice for the birthing and baptism of a totem pole. Isaac and Chip get the face marking, too. Norman then does the same for his father, Josiah Tait. His father has been unable to speak since suffering a stroke many years ago, so the elder Tait just smiles and holds Chip's daughter, Nellie. The carvers are all dressed in their new ceremonial tunics, leggings and headbands.

A flatbed truck arrives. The jovial crowd of pole bearers appears to be large enough to easily move the weight of this massive pole onto the truck. Norman picks up his drum and begins a slow beat that resonates through the thicket. The crew members gather, tense and focussed on the task at hand. Norman directs people to space themselves around the pole, with two people on each side of the crosspieces. He jumps up onto the pole and explains how the drum will be used to give directions for lifting.

Chip takes up his drum and the beat grows faster and louder. The pace quickens, backs bend. When the cadence stops with a resounding ''boom,'' everyone lifts. Slowly and carefully, the new totem pole is inched out of the shed into the sunshine. The pole is heavy and the way is barred by small saplings, so there are rest stops every few feet. With growing confidence, the pole bearers approach the waiting truck. Norman is pleased that this time human hands rather than machines are touching the pole; he feels it is being moved the right way.

Small roller logs are used to slide the pole onto the truck. Once the totem pole is carefully padded and secured, the carvers head for the Native Education Centre to welcome the pole when it arrives. The younger carvers are experiencing these Nisga'a welcoming traditions for the first time. Norman feels strongly that his crew must realize the importance of such ceremonies and know how to treat a totem pole with proper respect.

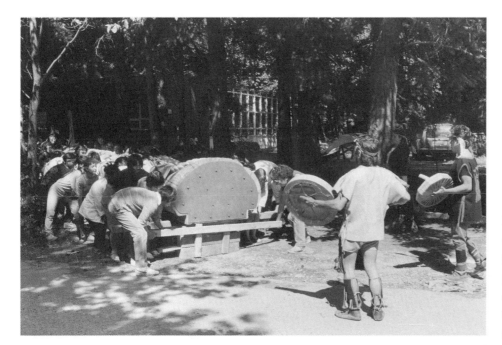

Norman and Chip beat their drums to give instructions for lifting the pole. The plate bolted onto the base of the pole is to help prevent decay from excessive moisture.

The bearers edge the 42-foot work of art onto the flatbed truck, which will transport it to the Native Education Centre.

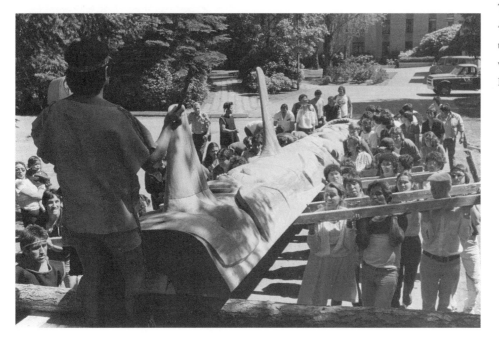

Even without the totem pole in place, the centre's new longhouse (or bighouse) is impressive. The scaffolding will be dismantled before the raising festivities.

Extended family members join the crew in a brief formal ceremony to welcome the pole to the site.

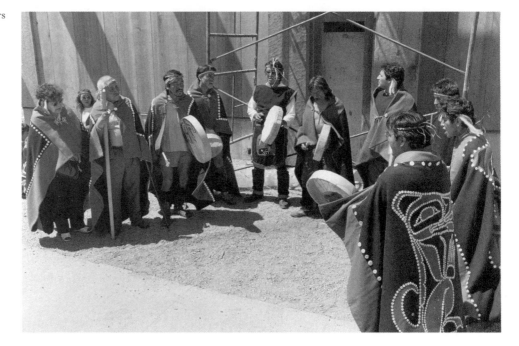

Half an hour later, the truck carrying the pole pulls up at the site. Its arrival signals the start of the ceremony. Robed in their button blankets, the apprentices join other family members to drum and sing a Nisga'a welcome to their pole, drawing on more of the traditions they have been learning.

People eagerly clamber aboard the flatbed trailer and gently ease the totem pole down onto the wooden supports waiting in front of the striking new building.

The small crowd is jubilant. The carvers, however, feel tense about the dangerous and complicated procedure of raising this pole in an urban setting, with so many power lines close by. Chip has already had a conference with Norman, discussing the details. "I told Norman, 'I've got a hundred and one questions.' He said, 'I'm ready for you, so go ahead.' Norman sketched for me what he wanted to do. I was worried because I'd never done that pole-raising before."

Chip is also aware of his brother's tension. "I could feel Norman starting to pull on me: 'Chip, let's go do this. Chip, I want to talk to you. Chip, this. Chip, that.' It's always that way when he's going to make a decision and he wants to bounce it off me. I do the same thing. We had to decide when and how we were going to do things and a lot of them were very, very big decisions."

For Isaac, at this stage the pole still signals work and worry rather than the satisfaction and pride of completion. He states, "Actually you're just waiting for the next step. You know, let's pull it up."

And that will happen tomorrow.

28 June

Three months ago, when Norman contracted to carve this totem pole for the Native Education Centre, the agreement stipulated the centre's responsibility for a proper raising of the pole. As the pole neared completion, Howard Green met with Norman to discuss the requirements for a pole-raising ceremony. Some of the obligations, such as ceremonial dress and appropriate dances and songs, are the responsibility of the carvers. However, other activities fall to the owner of the pole.

Howard recalls, "Norman explained that there should be a feast, and we would need a lot of people to help pull the pole up, and we would need to give a gift to those people that helped. So we took his design of the pole, got it silk-screened, did T-shirts and made it sort of a commemorative thing. Then we sent invitations out to hundreds and hundreds of people. We got three deer donated for the feast, and we got some students from the interior of British Columbia and from Manitoba to start cooking deer meat stew at six o'clock in the morning. Bannock is never a problem; we had lots. We served anyone who helped and wanted food."

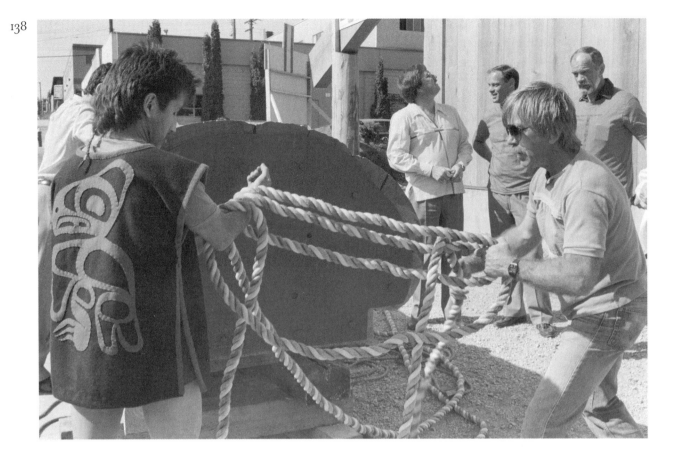

Hoisting ropes are rigged
so they can be released
after the raising. Padding
is also positioned so the
pole will not be damaged.

Chip outlines the crew's role in the pole-raising ceremonies. "We've got a program worked out. We will welcome the people, thank them for coming, instruct them as to how the totem pole will be raised and the stages in putting it up, tell them whose pole it is, name the pole, and then we leave it. We've done our job. We leave it for the people who wanted it, and that's practically everybody."

June 28 dawns as a picture-perfect day. In the quiet, rapidly warming summer morning, the carvers gather around the pole to adjust padding and to position the thick ropes. "We don't want to rope-burn our design, especially the edges," Chip explains. "But the pole takes wear and tear anyway as it goes up. They all do."

Earl Carter, who milled the log for the pole, shows up early. He and Wayne work at getting the ropes properly wrapped around the base of the pole's doorway and the Whale's tail. Chip explains, "The ropes have to be wrapped in such a way that once you pull them, they don't turn into a knot that will have to be cut off."

Once the ropes are correctly positioned around the pole, they are threaded through the pulleys mounted at the corners of the Native Education Centre's new longhouse- or bighouse-style building. The ropes extend out clear across the parking lot and across the street, which has been blocked off with police barricades. Norman considers a totem pole–raising to be a birthing, and the ropes are the umbilical cords.

Tait family members and other Nisga'a begin arriving with their regalia packed in suitcases and bags. The smallest children are dressed first and then walk around very conscious of their ceremonial finery and the special status it implies. Michelle Allen, Norman's young niece, is nervous and gets a hug of reassurance from her uncle. Mercy Robinson Thomas, the Wolf clan speaker who will name the pole, quietly reviews the sequence of events with Norman's mother, Sadie Tait. The carvers change into their tunics, leggings and headbands, then quickly head back to work. Hammy climbs up onto the roof of the building to run more ropes through pulleys.

The crowd begins to grow, gathering at first in the parking lot across the street. Most get a coffee or juice and pick up one of the bright-red commemorative T-shirts, designed with the Native Education Centre logo on one side and a drawing of the totem pole on the other. Soon people are spilling out into the street. A neighbouring business has strung up a banner welcoming the new Native Education Centre. Camera crews film the pole, the new building and anything "cultural" that moves. Reporters vie for interviews with Norman. Drums and Raven rattles are unpacked. An increasing number of people sport the red totem pole T-shirts.

Norman and Chip survey the crowd, occasionally acknowledging particular individuals and personally inviting them to help with the pole-raising. Chip

With a difficult pole-raising on his mind, Norman still takes time to give a reassuring hug to Hope's daughter, Michelle.

explains, ''I go out into the crowd and ask people that I know from the Nass River, especially. This pole is so traditional, with the nephews carving and the teaching and everything, that I want it to be experienced by people from the Nass and Prince Rupert so they will remember it. I saw one guy I used to work with and said, 'You're from Port Simpson. If you don't mind, you can take care of this . . . ' And he said, 'Sure, what do I do?' He was way older than Norman and me, but he just listened to what I said.''

Chip continues, ''In the village you wouldn't even have to go out and gather like that. The Port Simpson people would come and say, 'We're Eagles, what can we do?' And you'd write their name down. Then at the naming feast, you'd call out the list.''

Other men are working to fashion the scissorlike support piece that will go under the pole as it is raised. ''I picked Mercy's sons, Robert and Bruce Robinson, to tie the crosspieces,'' Chip says. ''They're two brothers from Kincolith, and they're Wolf. I showed them that the knot is one that can be slipped and what I wanted is to be able to scissor it. 'Oh, I get it,' they said and took over.''

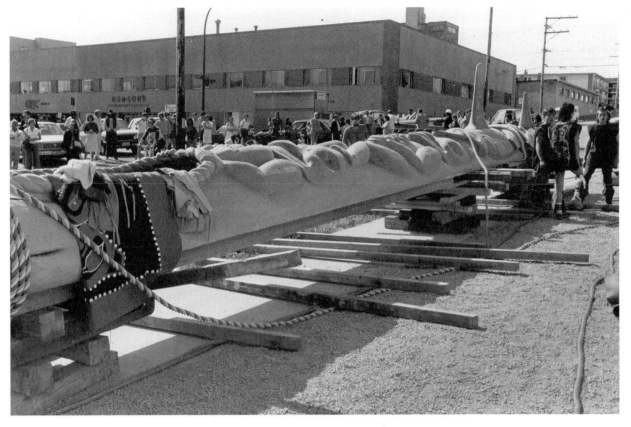

The crowd begins to gather. Long, thick ropes for pulling the pole upright stretch across parking lot and street.

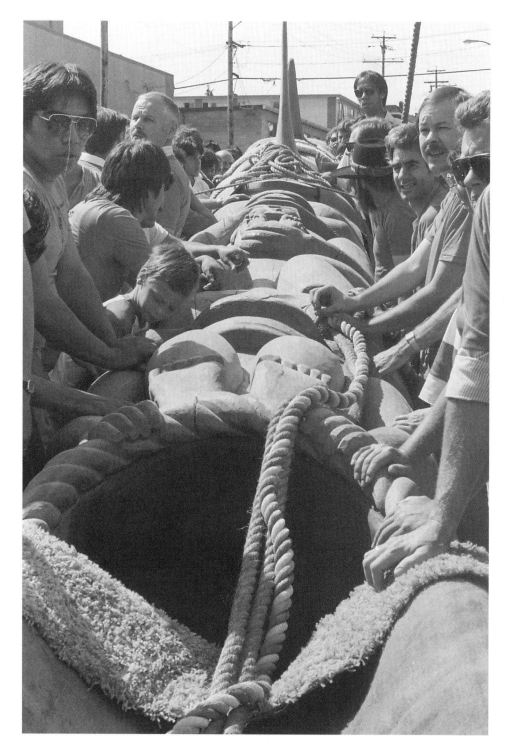

Ready to rotate the pole onto its side, the bearers are particularly mindful of the protruding beak and fin.

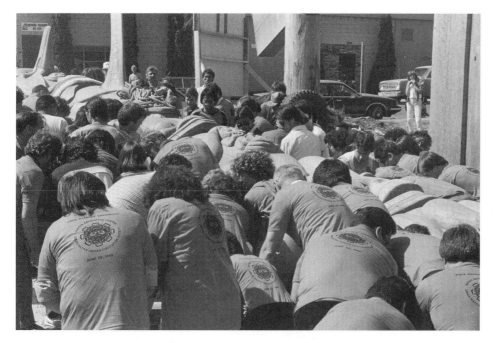

Their backs a sea of bright red commemorative T-shirts, participants wait for the first signal from the drum.

Hammy's brother, Clarence, also Wolf clan, begins drumming a slow, regular beat that kindles a sense of expectation in the crowd. Chip explains the job to him, saying, ''This is the beat to do, and you walk up and down. After a while, give the drum to somebody else, and you tell him how to do it. And as the pole gets closer and closer to going up, you drum faster and faster.'' As preparations continue, the drum passes to other people, who continue the pulsing beat.

Dressed in her button blanket, Wayne's oldest sister, Carol, circulates through the hundreds of people with an upturned drum, collecting the traditional donations to help defray expenses for the pole.

Chip addresses the crowd, explaining that the pole will have to be raised in two stages. The first is a delicate manoeuvre to turn it so that it is positioned on its side. The second stage is to raise the pole up and into position on the front of the building. While hundreds of people watch from the street, those surrounding the pole bend to lift and slowly rotate it, mindful of the delicate fin and beak. As that first rollover is completed, Norman's mother, Sadie, sings a song in Nisga'a, accompanied by other women of the Eagle clan.

Then the waiting crowd is directed to pick up the thick ropes that stretch along the front of the building and across the parking lot and street. Norman quietly touches the pole. Then taking his drum, he jumps up onto it and begins a strong beat that quickens the atmosphere. The supporting piece is readied under the

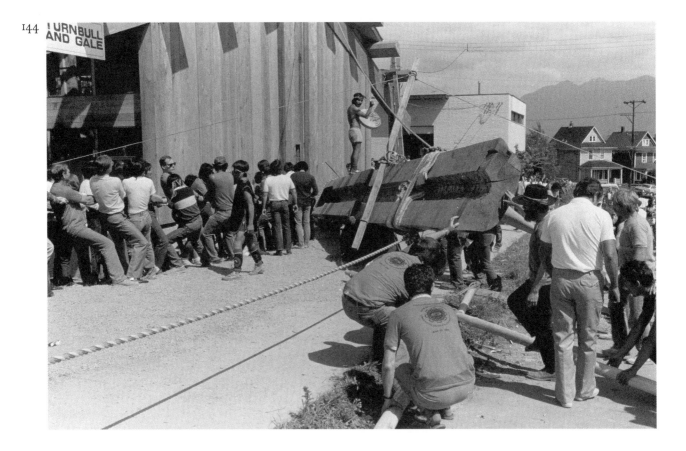

Norman instructs the
crowd as to which
drumbeats will signal the
various moves. Aware of
their responsibility, the
crowd pays close
attention.

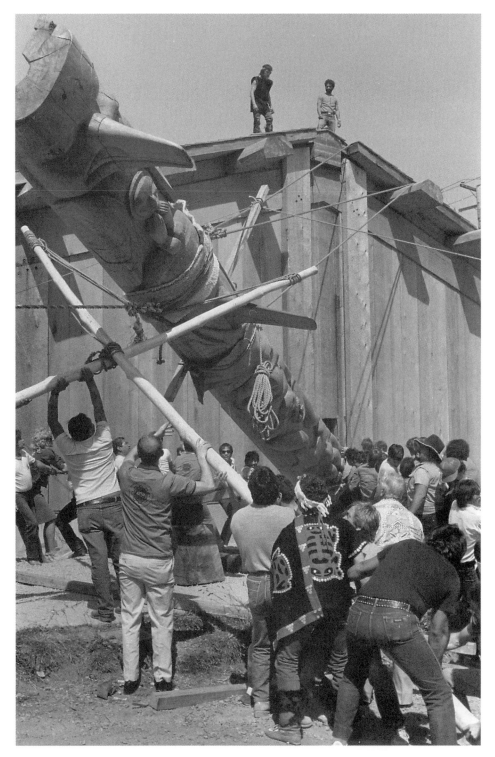

Tension increases as the pole slowly inches upright. The support, or crutch, is continually repositioned.

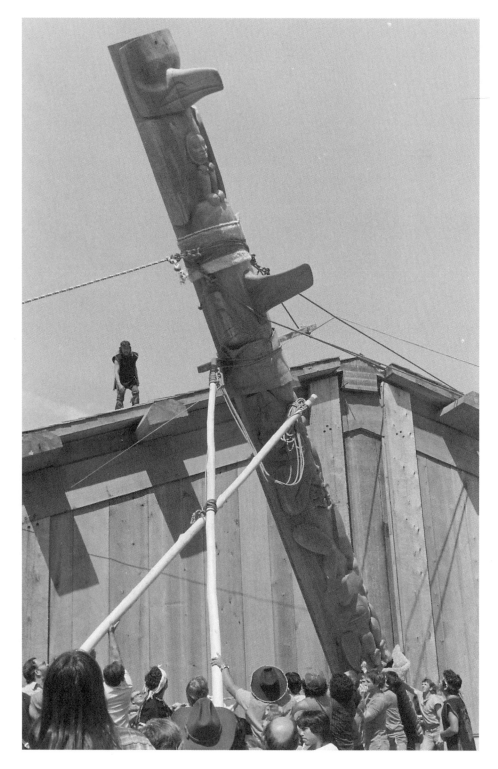

This co-ordinated effort involves hundreds of people pulling on numerous ropes, some of which raise the pole upright; others rotate the pole outward.

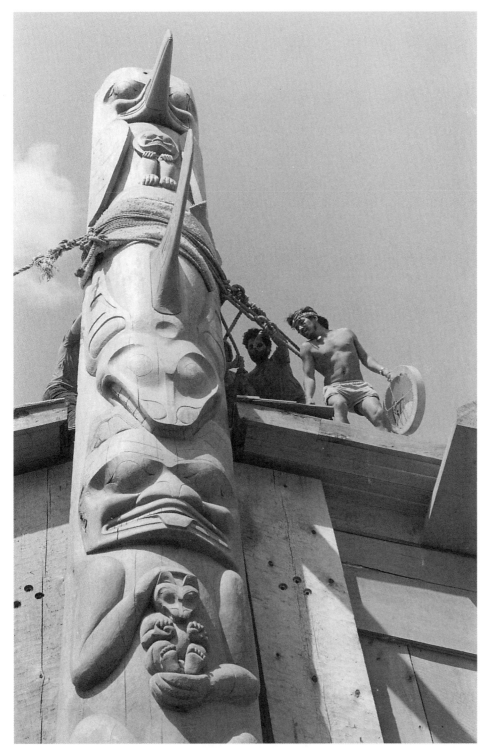

Although the pole is now
vertical, it still needs to
be moved so it is flush
against the building.

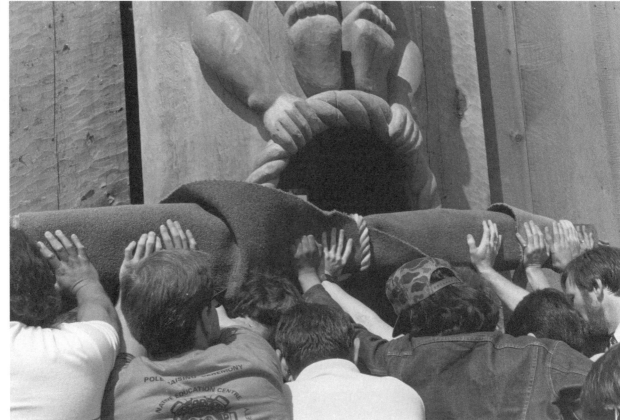

In a final effort to bring
the butt end into position,
one pole bearer exhorts
the others, "Do you see
your power? You can
move it!"

pole. Hundreds of hands grip the ropes and begin to pull. Even passing business-men in suits and ties stop to lend their strength.

The ropes are pulled taut. Slowly, the totem pole begins to rise. Each time it is pulled up a few inches, the scissored support is moved under the pole at a new place. There are several pauses to reposition ropes or have one group pull while another line eases off. Pullers brace their legs and lean back, both to inch the pole higher and to hold it in position. With ropes tight as bowstrings, the pole moves closer into position at the centre of the building. Still carrying his drum, Norman joins Hammy and a few others on the roof to oversee the last pulls. Finally, the pole is vertical, silhouetted against the blue summer sky. But the base is still several inches out of position. It will require sheer muscle power to move the now upright pole and snug it against the building. A neighbouring engineering firm offers to send equipment over to move the pole into position. Norman thanks them for their offer but is determined to continue with human power alone.

A number of men quickly head inside the building, while others position them-selves outside. Two or three ropes are run inside through the doorway. The first time they pull on the ropes, the pole moves a slight bit.

"Do you see your power?" one encourages the rest. "You can move it."

The tired group responds, "Yeah, right!"

"O.K., now, one more time," the directive comes. Muscles tense for a second try. And with that effort, the base of the pole slides into place. The crowd is elat-ed! All tension evaporates as applause, cheers and whistles fill the hot summer air.

Full of high spirits, the carvers call Hammy down off the roof as soon as he has secured the pole with ropes: "Hammy, come on dowwwwwwwn!" A round of hugs among the crew follows. Tears fill the eyes of Norman's mother and others in his family.

With relief and jubilation, the carvers embrace various family members. Isaac has tears streaming down his cheeks as he shares a long hug with his sister, Valerie. "I'm someone who holds back to the very end," he explains. "When the beak went on, I didn't feel anything special, but when it's all over, I start to shake. I really feel it then."

Chip recalls, "When I looked up at the pole, I just felt like crying. I couldn't believe it, after all that. I knew it was finally over. I knew where I was. I had my little girl, the whole family was with me. It's something that a lot of people never experience."

Norman admits, "Emotions get the best of me, so sometimes I sort of hide away for a minute or two. I am supposed to keep up the tradition of a strong leader, to keep my head up. But when I watch my son Isaac, Wayne, my brother Chip, Hammy—I feel like I've just brought up a whole family of kids, and now

With the pole safely raised, the Tait family beams their pride. In the foreground Norman shares a hug with Mrs. Hazel Frew.

Hammy's younger brother, Clarence Martin, joins Chip and Hammy in a brotherhood handshake.

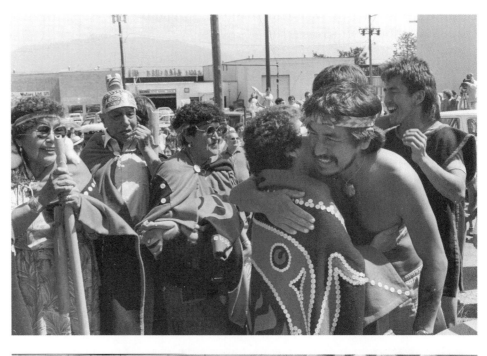

Hardly able to believe
that three months of
intensive labour are over,
Hammy and Isaac hug
and grin.

they're men. Your heart swells. And then I have to go out and take a deep breath before I can come back.''

Norman's father is accorded the honour of being the first to step through the pole's doorway. Then the construction crew and Martha Aspinall, president of the Native Education Centre, gather by the pole for a group portrait. Past frustrations forgotten, Norman and Earl Carter hug and then take their places for the photograph. Norman stands with his drum in one hand and a popsicle someone has given him in the other, his responsibilities nearly over.

With the pole safely raised and lashed in position, it is time for the ceremonies to begin. Norman's painted dance screen is hoisted up against the building. The carvers locate their drums and don their button blankets. Norman puts on the Eagle helmet he carved years earlier and borrowed back for the occasion from the Vancouver Museum's collection. With drum and eagle feathers in hand, he moves to the ceremonial doorway. Joined by his mother and the carvers, Norman sings and then dances his Eagle dance. After that, the carvers, clad in full regalia, sing their song.

Next, Norman tells the story of the pole to the attentive crowd. Then comes the official naming of the pole. Wolf clan chief Mercy Robinson Thomas, or Nisibilaada, is also clad in regalia. Solemnly, she calls out three times:

Dim am'ayees, Wil Sayt Bakwhlgat.
Dim am'ayees, Wil Sayt Bakwhlgat.
Dim am'ayees, Wil Sayt Bakwhlgat.

She uses a traditional way to acknowledge someone's new name or status, which translates: ''You will walk straight, Wil Sayt Bakwhlgat.''

According to Nisga'a belief, now that the pole has been named, it awakens from its dormant state and is considered a living being. Mercy is presented with a drum and Wolf-design vest as her gifts for naming the pole. Norman explains, ''That was Mom's special thank you to Mercy for all she has done for our family.''

Appropriately, the name Wil Sayt Bakwhlgat means ''the place where the people gather.'' A plaque on the building announces: ''This pole is dedicated to all Indian people who have gone on before, to those who currently struggle for our survival, and to the generations yet unborn.''

As Howard Green notes, ''This whole building, and the pole particularly, has been a source of pride. We could have done it a lot cheaper without a pole and with a cement-block building, but then it would have been just like any other building in Vancouver. At a museum, people are looking at death, at what was. We want to say, 'We're here! Native people are alive!' The name of the pole states, 'the place where the people gather,' and that's what it's all about.''

Speeches follow the naming of the totem pole. First, Salish chief Percy Paul

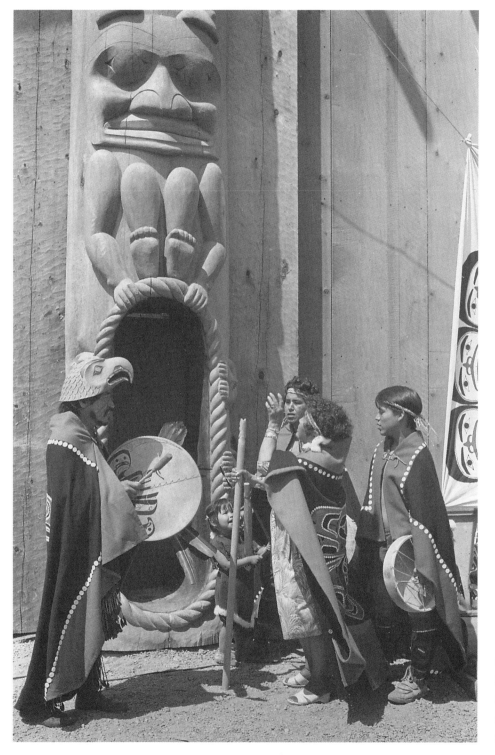

Wearing the Eagle crest
helmet he carved,
Norman drums as his
mother sings a Nisga'a
song to the pole.

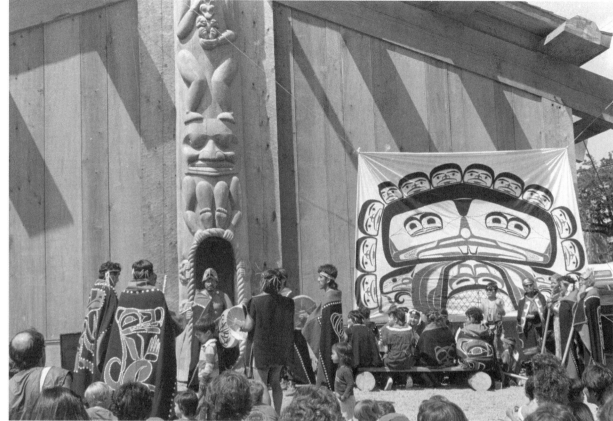

In front of the dance
screen that Norman has
designed and painted,
crew members don their
button blankets and
gather their drums for
the final ceremonies.

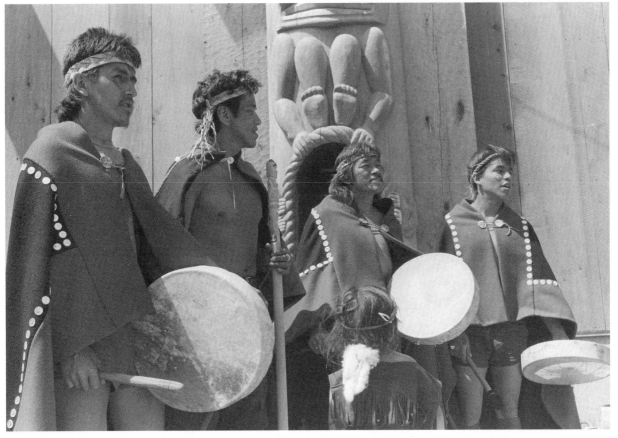

"I feel like I just brought
up a whole family of
kids, and now they're
men. Your heart swells,"
says Norman.

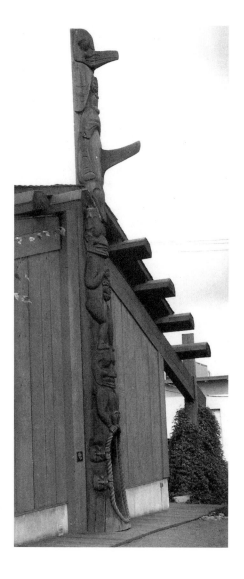

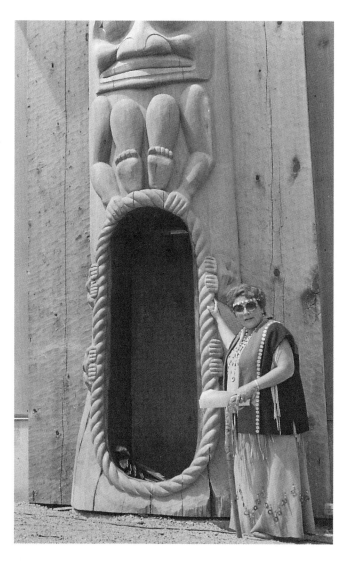

The finished pole
Wil Sayt Bakwhgat
(Where the People
Gather) in place at the
Native Education Centre,
285 East 5th Avenue,
Vancouver, B.C.

Wolf clan chief Mercy
Robinson Thomas calls
out the pole's name three
times to the crowd who
witness the event. "You
will walk straight, Wil
Sayt Bakwhgat."

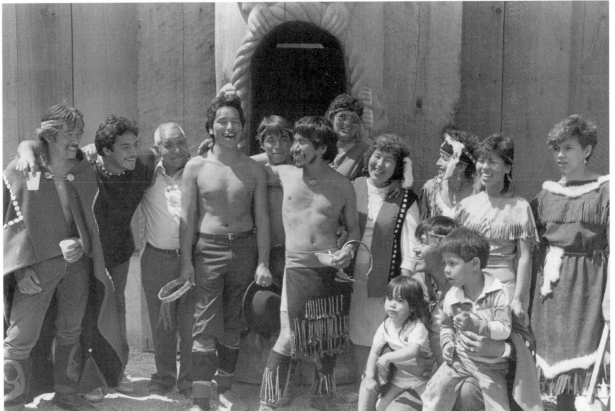

welcomes the crowd, as the pole is being erected on land where the Salish once lived. Then Martha Aspinall, Norman Tait and Howard Green speak, flanked by Nisga'a wearing button blankets. These speeches mark the completion of the ceremonies. Tomorrow, construction workers will bolt the pole permanently in place. With a last, skyward look at the pole, the crowd begins to disperse.

Finally, there is time for the carvers to eat a bowl of deer stew themselves. They can also savour the final payment that the director hands over to Norman. It has been almost three months to the day since Norman signed the totem pole contract.

There is a last round of family portraits, this time with everyone smiling and relaxed. The carvers and their family members seem reluctant to pack up and leave. But the job is over. This monumental totem pole that they have learned on and laboured over is no longer theirs. Wil Sayt Bakwhlgat has its own life now.

APPENDIX 1

APPENDIX 2

SELECTED BIBLIOGRAPHY

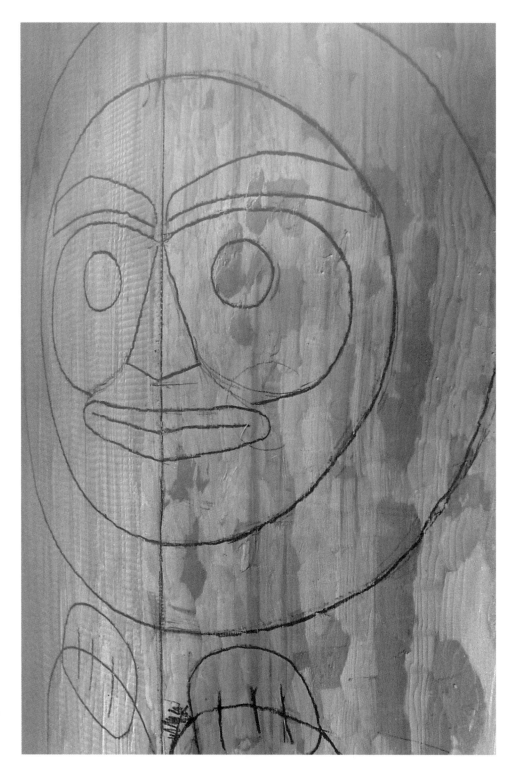

"The tracing is a way to make sure the figures don't clash. Once both sides are drawn on, you can step back and see whether the figure is too crowded, too small or too big—or that it works," explains Chip.

VISUAL RECORD *of the*

MOON FACE FIGURE

Photography offers the rare opportunity to record and study the progress of totem pole figures as they are carved. This appendix focusses on the Moon face that is cradled between the Raven's wings. The pictures begin with the first sketch and end with the final finished figure.

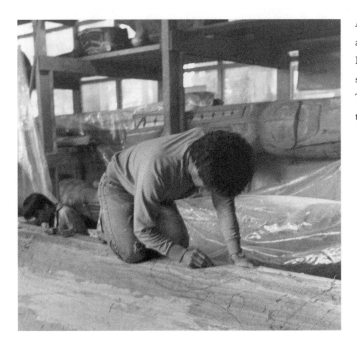

After measuring off the area for the Moon face, Norman begins a rough sketch that fills the space. The facing page shows the finished sketch.

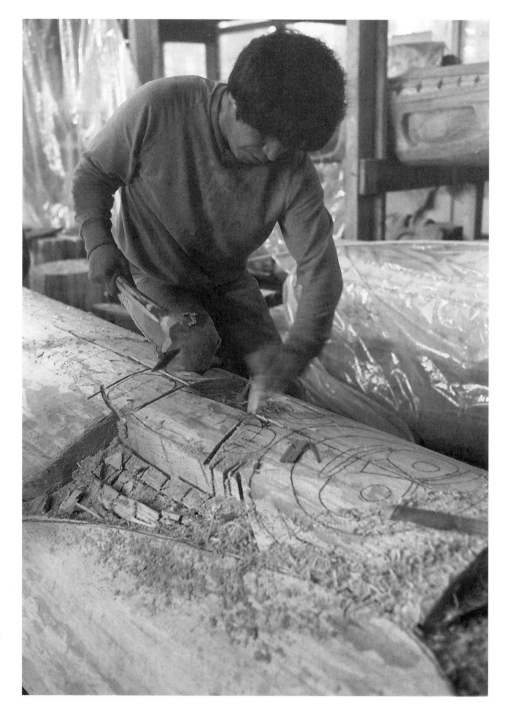

Swiftly blocking out the legs, Norman cuts the knees and ankles to depth with the chainsaw. Then he knocks out the wood with his adze and a stick.

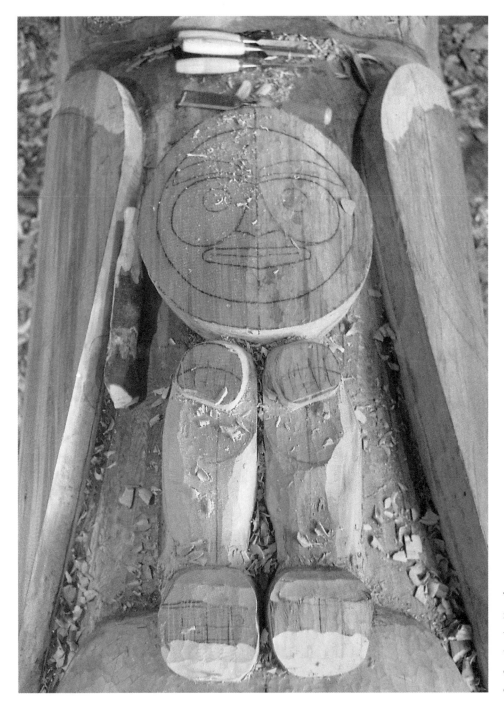

The figure has now been rough cut. Most of the wood has been taken out, the hands and feet defined, the legs tapered down to the ankles.

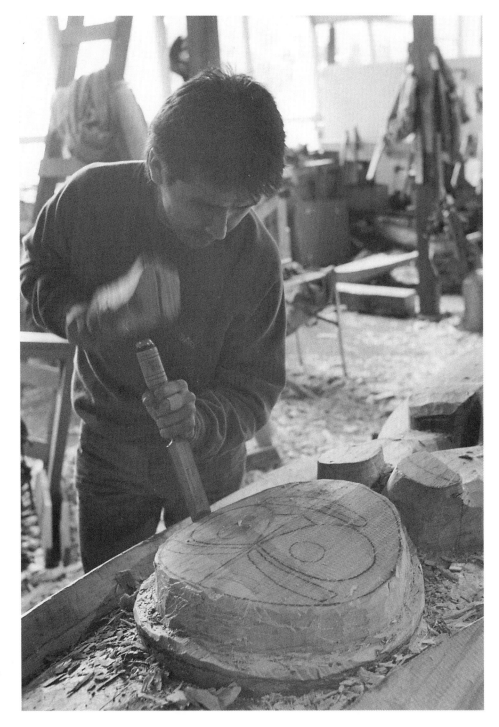

Wayne uses his mallet
and chisel to cut down
the outer ring of the
Moon face.

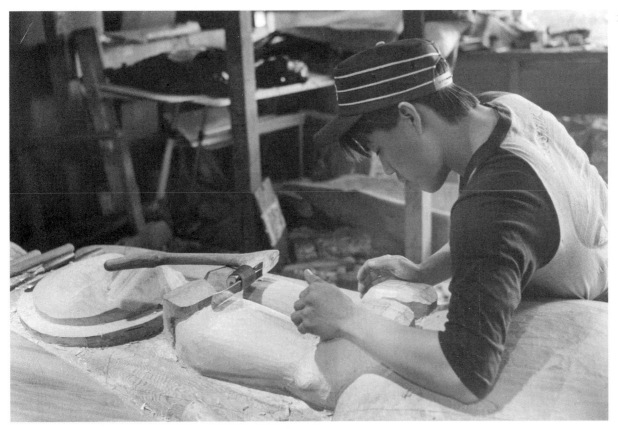

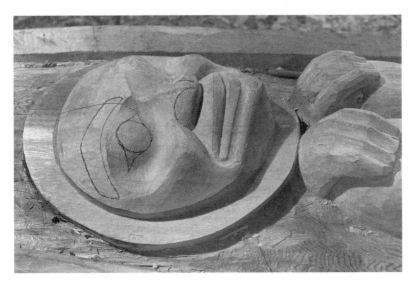

Once the figure has been rounded to a smooth, sculptured form, Isaac begins defining its fingers and toes.

At the finishing stage, the Moon face is already striking. Only the nostrils, eyes and eyebrows await detail work.

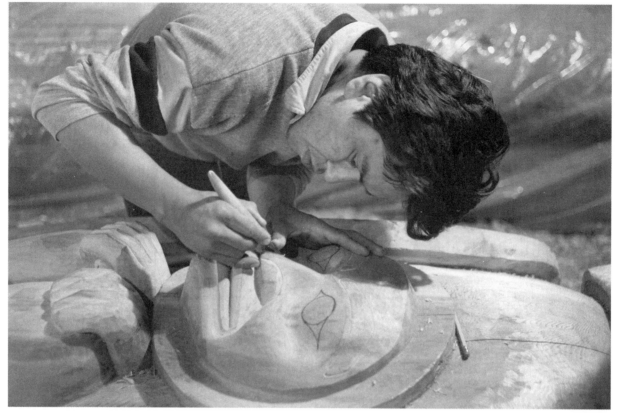

Chip uses his straight
knife to outline the
Moon's features with
careful V-cuts.

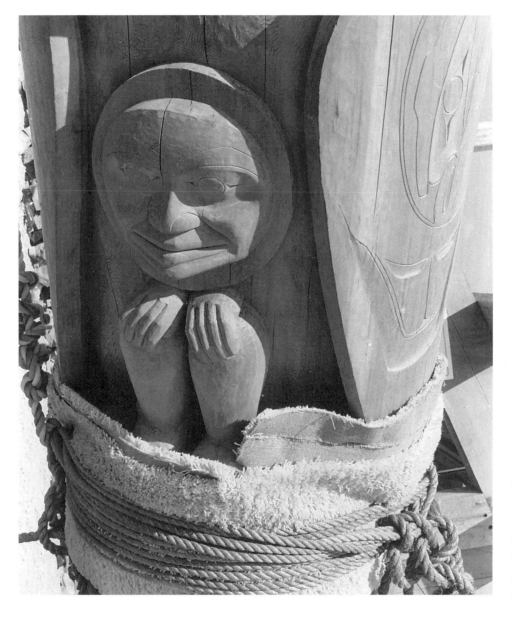

Still wrapped for
protection from the
ropes, this is the first
time the finished Moon
face looks at the world
from the pole's vertical
position.

In 1973, Norman Tait's first totem pole, 37 feet tall, was the first Nisga'a pole to be raised in over half a century. *District of Port Edward and Museum of Northern B.C.*

NORMAN TAIT:

LIST *of* MAJOR WORKS

1973 This 37-foot four-crest tribal unification pole is Norman Tait's first totem pole, carved with the help of his father, Josiah Tait. It commemorates the incorporation of Port Edward and is erected there.

1975 The 18-foot Beginning of Man pole stands outside the head office of the first native-run cannery in Port Simpson. The story for this pole is a much shorter version of the story for Wil Sayt Bakwhlgat, as related in Lizanne Fisher's unpublished M.A. thesis, "Big Beaver: The Celebration of a Contemporary Totem Pole by Norman Tait, Nishga." Norman confirms this fact, stating, "I didn't have the whole story for that small pole. When I finished it, I realized how much I didn't know about that story, so I went back and learned more."

1976 An 11-foot Raven clan pole and Beaver House copper were commissioned for the opening of the National Museum of Ethnology in Osaka, Japan.

1976 Norman started a 25-foot pole in Vancouver and finished carving it as part of a Northwest Coast demonstration at the Heard Museum in Phoenix, Arizona. The pole is painted and is part of the museum's collection.

1978 The 15-foot Frog clan pole that stands on the grounds outside the University of British Columbia's Museum of Anthropology was carved as a demonstration at the museum. This pole is largely unpainted, except for red and black accent colours on the faces of the figures and is carved in a shallow style.

1978 A 10-foot by 32-foot four-crest mural was commissioned by the Department of Indian Affairs. It decorates the Hartley Bay School, in Hartley Bay, B.C.

1979 An 11-foot Raven and Moon pole has a chief holding his grandson at the base. It stands in the library of St. George's Senior School in Vancouver, B.C., and was donated by Derek Simpkins. This is one of Norman's first unpainted poles.

1980 The 25-foot unpainted Eagle crest pole was carved at the M. H. de Young Memorial Museum of Fine Arts in San Francisco as part of a demonstration. After being stored briefly at the museum, it was raised at the home of a private collector.

Spectators watch as the 55-foot Big Beaver pole is raised in front of the Field Museum of Natural History, Chicago, in 1982. *Photograph by Tom Hawker, Field Museum of Natural History, 82-20-13*

1980 The Wolf clan of the Nass River commissioned a speaker's staff for the installation of the Bishop of New Caledonia.

1980- Over a period of several years, Norman Tait produced three canoes, ranging from 15 to 23 feet in length. He supervised six apprentices in carving two of the Nisga'a canoes for a journey to Prince Rupert and the Nass River. The third came about when he was invited to demonstrate carving a traditional canoe at the annual Canoe Festival in Ottawa, Ontario.

1981 A pair of doors for a restaurant in Horseshoe Bay, near Vancouver, B.C., depicts the clans and crests of Kincolith, the village in which Norman was born: Eagle and Beaver crests for the Eagle clan, Wolf and White Grizzly crests for the Wolf clan, Raven and Frog crests for the Frog clan, Killerwhale and Owl crests for the Killerwhale clan.

1981 A 7-foot welcome figure carved by Norman was donated by Derek Simpkins to the University of British Columbia's Museum of Anthropology. This figure inspired Joe David to carve a much larger welcome figure.

1982 The 55-foot Big Beaver pole was another demonstration project with Norman's brother Alver Tait, Mitchell Morrison, Chip Tait, Lawrence Wilson and Teddy

Members of the greater Tait family gather at the base of the smaller 30-foot Capilano Mall pole, after its raising.

Barton. It stands in front of the Field Museum of Natural History in Chicago, Illinois. The carving of this pole is well documented in Lizanne Fisher's unpublished M.A thesis, "Big Beaver: The Celebration of a Contemporary Totem Pole by Norman Tait, Nishga."

1983 An 11-foot pole (location not known) was carved by Norman with six apprentices while he was supervisor of construction for the carving shed at Expo 86 in Vancouver.

1985 The 42-foot Wil Sayt Bakwhlgat pole forms the ceremonial entrance of the Native Education Centre in Vancouver, B.C.

1986 Two strikingly unusual poles, one 45 and the other 30 feet tall, are carved "in the round." Each totem pole log has been cut and carved; in addition, each of the back slabs has also been carved and mounted in place behind the poles. The smaller pole was a demonstration carving inside the Capilano Mall in North Vancouver, B.C., where both poles stand. Norman Tait's daughter, Valerie, and his nephew, Ron Telek, worked on these poles, as did Nisga'a Carlos Verde. Chip Tait served as foreman and Isaac Tait was a member of the crew. (There is also extensive photo documentation of these poles by the author.)

1986 A small 12-foot pole was commissioned by a private collector.

1987 On this 38-foot pole, Chip Tait was again foreman, working along with Isaac Tait. Ron Telek was on the crew for the early stages of the pole, designed for Vancouver, B.C.'s Stanley Park and its thousands of visiting tourists. Norman Tait originally planned that this pole would have a large open area at the base where tourists could link arms with a lower figure on the pole and have their picture taken. (Work on this pole is also documented by the author.)

1990 The wood for this 42-inch diameter Moon mask came from the end cuts of the Wil Sayt Bakwhlgat pole. It was sold to a private collector.

1991 A 12-foot totem pole entitled Two Brothers was carved as a demonstration and depicts the story of the Tait family's history on the north coast of British Columbia.

1991 This 37-foot Killerwhale-Eagle pole was carved as a demonstration at the Stirling University Art Festival in Stirling, Scotland. The pole stands in Bushy Park, Richmond, in London, England. In conjunction with the raising of this pole, Norman Tait was invited to Buckingham Palace to be presented to Her Majesty Queen Elizabeth II.

1992 Awarded the Commemorative Medal for the 125th Anniversary of Canadian Confederation, given to persons who have made a significant contribution to Canada, to their community, and to fellow Canadians.

1995 The eagle body and wings of the 55-foot Big Beaver pole were recarved and replaced at the Field Museum in Chicago.

1996 The National Geographic Society and Tait's Wilp's Tsa-ak Gallery created a painting project of a 9-inch yellow cedar totem pole to be sold in their 1996 catalogue. The original of this small Raven and Moon pole was subsequently purchased by The Royal Museum of Edinburgh.

1996 The 4-foot x 15-inch eagle sculpture Simoeget Alethgat was commissioned by the Vancouver Stock Exchange and is on permanent exhibit in their executive boardroom.

1996 Seven yellow cedar doors were carved for a private collector in Whistler, B.C.

1997 A second sculpture depicting a salmon leaping over a maple burl was commissioned by the Vancouver Stock Exchange and is on permanent exhibition there.

1997 A 40-foot totem pole was commissioned by the Nisga'a Tribal Council. Raised in 1999 as a commemorative boundary pole with the Tsimshian and Nisga'a.

1997 Royal presentation by Governor General Romeo Leblanc and his wife Diana Fowler-Leblanc to Their Royal Highnesses Princes Charles, William and Harry on their visit to Vancouver.

1998 A 20-foot totem pole carved on site at the Pacific National Exhibition in Vancouver for a private collector.

1998 First release of the limited edition (12) Eagle Frontlet bronzes.

1998 Private commissions included a 15-foot family totem pole and a yellow cedar door.

1998 The Strong Man Whale Tail sculpture was commissioned for the National Aboriginal Cultural Foundation's corporate collection. The image will be used for the National Aboriginal Achievement Awards program.

1998 Presented with a FANS Arts Achievement Award by the North Shore Arts Commission and subsequently featured on the cover of *Arts Alive* magazine and in a TV documentary.

1999 The 15-inch Ladle of 12 Faces seamonster spoon carved with Lucinda Turner in collaboration with Milton Wong for the Canadian Craft Museum's ''Unexpected Collaborations'' sold for a record price at the benefit auction.

SELECTED BIBLIOGRAPHY

This annotated bibliography contains selections of interest for the general reader, and is divided into three parts. The first part lists some additional materials that feature Norman Tait and his work. The second part covers books that provide a basic introduction to Northwest Coast native art, totem poles, carving tools and regalia. The third part focusses on Tsimshian culture and historic totem poles.

Norman Tait
Field Museum of Natural History. "Big Beaver Comes to Field Museum," *Museum Bulletin*, June 1982.

 Written for museum members, this article describes the carving and raising ceremonies of Big Beaver, the 55-foot totem pole that now stands in front of the Field Museum in Chicago.

Fisher, Lizanne. "Big Beaver: The Celebration of a Contemporary Totem Pole by Norman Tait, Nishga." M.A. thesis, University of British Columbia, 1985.

 This academic work has extensive biographical information and looks at the adaptation of old Nisga'a traditions to contemporary expression in the production of a specific pole.

Macfarlane, Natalie, and Stephen Inglis. "Norman Tait: Nishga Carver," *Museum Notes* (University of British Columbia Museum of Anthropology, Vancouver), 1977.

 Although dated, this small brochure contains some biographical information and discusses Norman Tait's early work. It was published in conjunction with his one-man exhibition at the museum.

Northwest Coast Art and Culture
Arima, E. Y., and E. C. Hunt. *Making Masks: Notes on Kwakiutl "Tourist Mask" Carving.*

Canadian Museum of Civilization Mercury Series, No. 31. Hull, Quebec: Canadian Museum of Civilization, 1975.

Although this article focusses on Kwakwaka'wakw masks carved for the tourist market, it also contains a good general description of the manufacture and use of carving tools.

Halpin, Marjorie. *Totem Poles: An Illustrated Guide.* Museum Note, No. 3. Vancouver and London: University of British Columbia Press, 1981.

This well-illustrated book provides an encompassing description of totemism, types of totem poles and the carving styles of various native groups on the Northwest Coast.

Holm, Bill. *Northwest Coast Indian Art: An Analysis of Form.* Thomas Burke Memorial Washington State Museum Monograph, No. 1. Seattle: University of Washington Press, 1965; Vancouver/Toronto: Douglas & McIntyre, 1965.

A readable book that analyzes, codifies and labels the conventions of Northwest Coast art. It established the vocabulary that has since been used to discuss the design elements of this art.

Jensen, Doreen, and Polly Sargent. *Robes of Power: Totem Poles on Cloth.* Museum Note, No. 17. Vancouver: University of British Columbia Press and the University of British Columbia Museum of Anthropology, 1986.

A look at the symbolic meaning, production and use of regalia, along with interviews and photographs of contemporary button blanket designers (including Norman Tait) and their work.

Macnair, Peter L., Alan L. Hoover and Kevin Neary. *The Legacy: Tradition and Innovation in Northwest Coast Art.* Vancouver/Toronto: Douglas and McIntyre, 1984; Seattle: University of Washington Press, 1984.

This excellent introduction to Northwest Coast native art covers both art and culture, including early history, an analysis of flat design and good contemporary material. There is specific mention of Norman Tait, as well as a section on contemporary Tsimshian art.

Stewart, Hilary. *Looking at Indian Art of the Northwest Coast.* Vancouver/Toronto: Douglas & McIntyre, 1979; Seattle: University of Washington Press, 1979.

A well-illustrated primer that introduces the artistic conventions of Northwest Coast art and identifies characteristics of basic totemic figures.

————. *Totem Poles.* Vancouver/Toronto: Douglas & McIntyre, 1990; Seattle: University of Washington Press, 1990.

Drawings of and anecdotal information about more than 100 totem poles in British Columbia and Alaska which are situated outdoors and accessible for viewing and/or study. Includes poles by Norman Tait.

Tsimshian Culture and Historic Totem Poles
Barbeau, Marius. *Totem Poles,* 2 Vols. National Museum of Canada Bulletin, No. 119, Anthropological Series, No. 30. Ottawa, 1950.

_____ . *Totem Poles of the Gitksan, Upper Skeena River.* B.C. Anthropological Series, No. 12, Bulletin, No. 61. Ottawa, 1929.

Barbeau's early ethnographic studies describe poles in their cultural setting. These Barbeau works have been reprinted and are readily available.

Garfield, Viola E., and Paul S. Wingert. *The Tsimshian Indians and Their Arts.* Seattle: University of Washington Press, 1966.

A short, popularly written description of traditional Tsimshian culture and art, somewhat dated. General in nature, it does not specifically treat Nisga'a as a subgroup.

Riley, Linda, ed. *Marius Barbeau's Photographic Collection: The Nass River.* Canadian Museum of Civilization Mercury Series, No. 109. Hull, Quebec: Canadian Museum of Civilization, 1988.

The catalogue of Barbeau's black-and-white photographs from the museum's collection includes brief data regarding each pole's name, the figures on it, the owner and original location, as well as what happened to it, where such information was available.

Suttles, Wayne, ed. *Northwest Coast, Handbook of the North American Indian,* Vol. 7. Washington, D.C.: Smithsonian Institution, 1990.

This recently updated work on the Northwest Coast contains cultural information including art, ceremony, language, prehistory and social organization of both Coastal and Riverine Tsimshians. There is a photo of Norman Tait on page 292.